colourful world

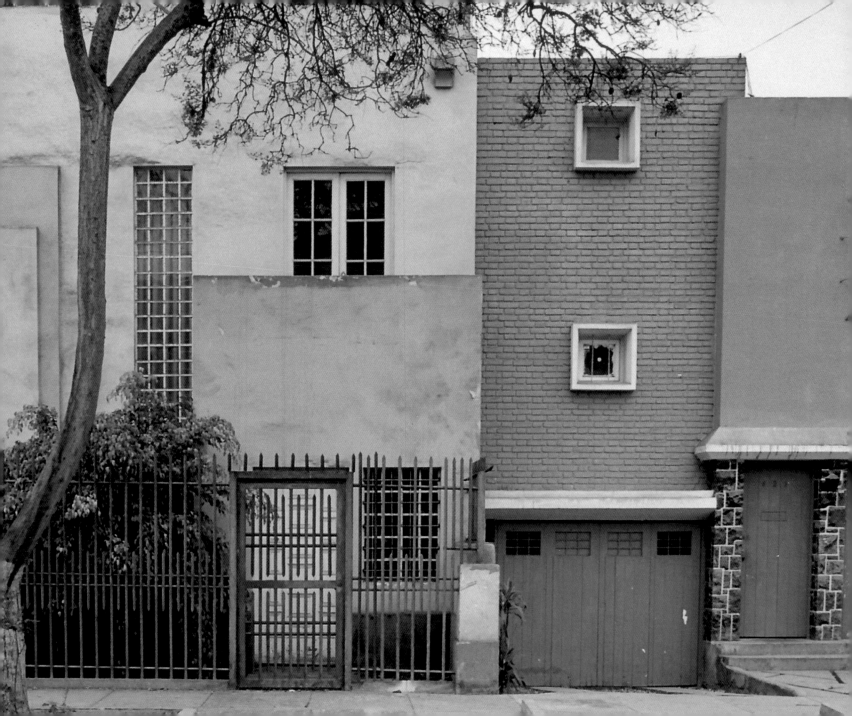

Preface Hilton McConnico

People often ask me what my favourite colour is, and seem a little frustrated when I reply that I don't have one. I like all colours in fact. But what pleases me more than a particular colour, is the juxtaposition, interplay and relationship between several at once.

Nature provides us with an unlimited array of colours, yet it is the palette created by humans, either by accident or intentionally, that never ceases to amaze me.

One of the first things I learnt when I moved to France was that you don't discuss 'taste or colour'. Maybe I have been conditioned by my work, or perhaps because of personal taste, or even coincidence, but I have always found that colour comes up frequently in conversation:

'What a grey day!'
'Look at the bird with the blue feathers!'
'I would like the doll with the pink bow.'
'It was a bolt from the blue.'
'I am green with envy.'
'What it this purple flower called?'
'A red-berry ice-cream.'

A few years ago, Amandine Guisez and I had the opportunity to work together, and I was immediately struck by her interest in colour. More recently, when she showed me the photographs she had taken all over the world, I realised that she had managed to capture the multitude of colours that define the visual space of our planet.

Thanks to Amandine's unique perspective, and to photographs such as these, men and women will finally have the opportunity to experience life surrounded by a balancing and beneficial kaleidoscope of colours.

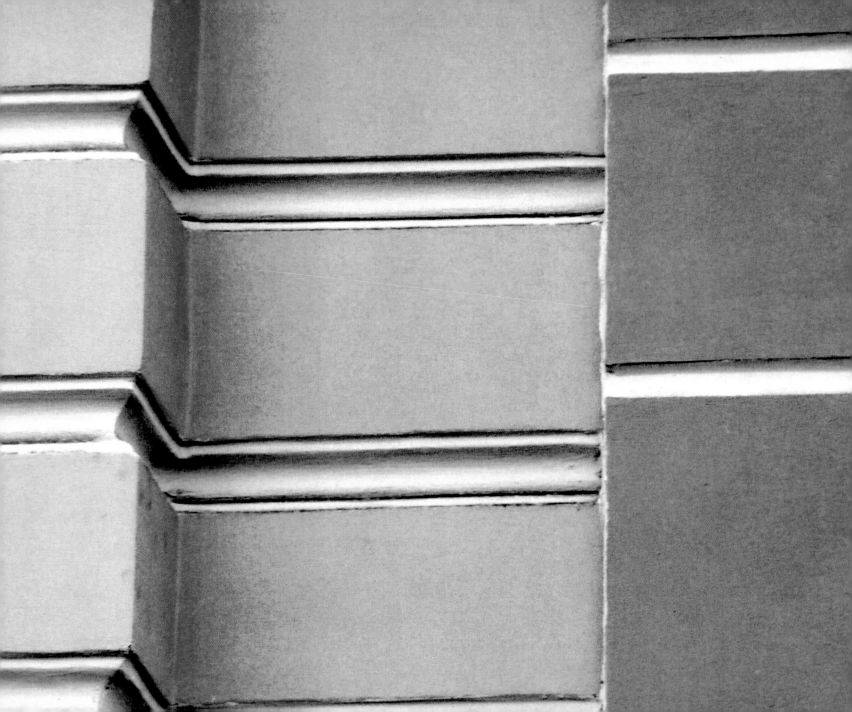

Introduction

From Mali to Peru and from China to Norway, through Mexico, Japan, India, Greece, Russia and Finland, I travelled with a single purpose in mind: to discover, and then to reveal to others, the colours of the world. Not the colours of nature, of flora or fauna, but those created and carefully selected by human beings to keep them company, enhance their dwellings and beautify their clothing.

Deeply intrigued by colours, and by the way mankind has always sought self-expression through them, I wanted to understand their symbolism in each one of the cultures I encountered: to discover what they mean, and what emotions they arouse. This book is not an exhaustive and profound study of the meaning of colours, but rather a celebration of human creativity.

This search for colours led me to all sorts of places, from the most commonplace to the most unexpected, including private and very intimate spaces. A paper-making workshop in the suburbs of Jaipur in India, a market in a little industrial town in Peru, a cochineal farm in the middle of a vast desert area in Mexico: these are some of the places to which I was led by chance in my wanderings.

In the course of what was for me a true voyage of initiation, I discovered a passion that knows no political frontiers. Throughout the world, those who deal with colour speak the same language, a language concerned with the intensity, brilliance or depth of a particular tone, value and shade. These craftsmen are amazing alchemists and have a passion for chemical formulas that are completely incomprehensible to a novice. Like musicians, they vibrate to the same rhythms, and imagine shimmering scores punctuated by chromatic notes. They are the creators of a colourful world. This book is dedicated to them.

white

egg white, off white, lily white, milk white, snow white, as white as a sheet, china white, white gold, pearl white, whitewash, lead white, titanium white, white-hot, white sands, white chocolate...

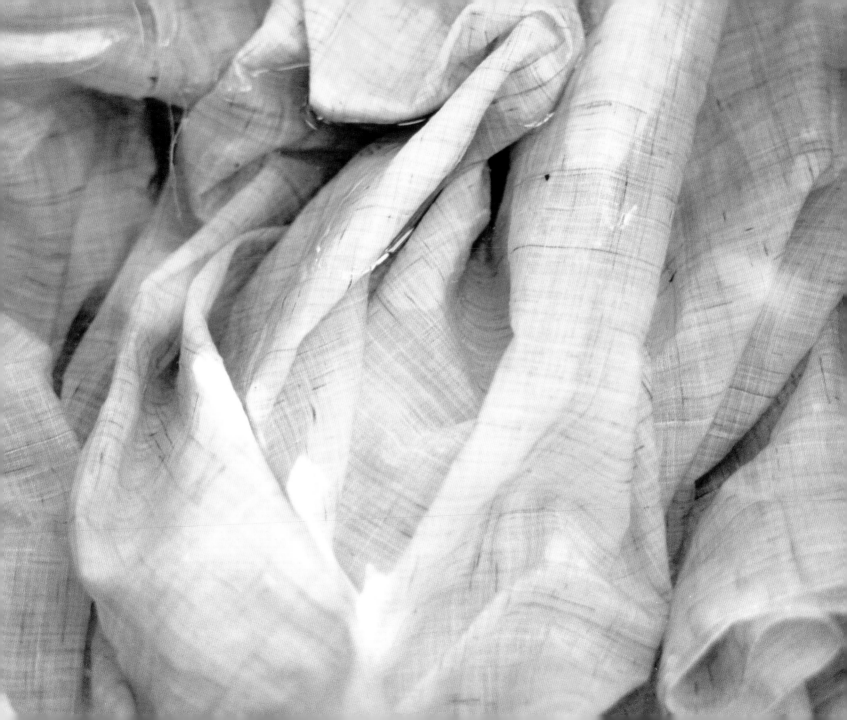

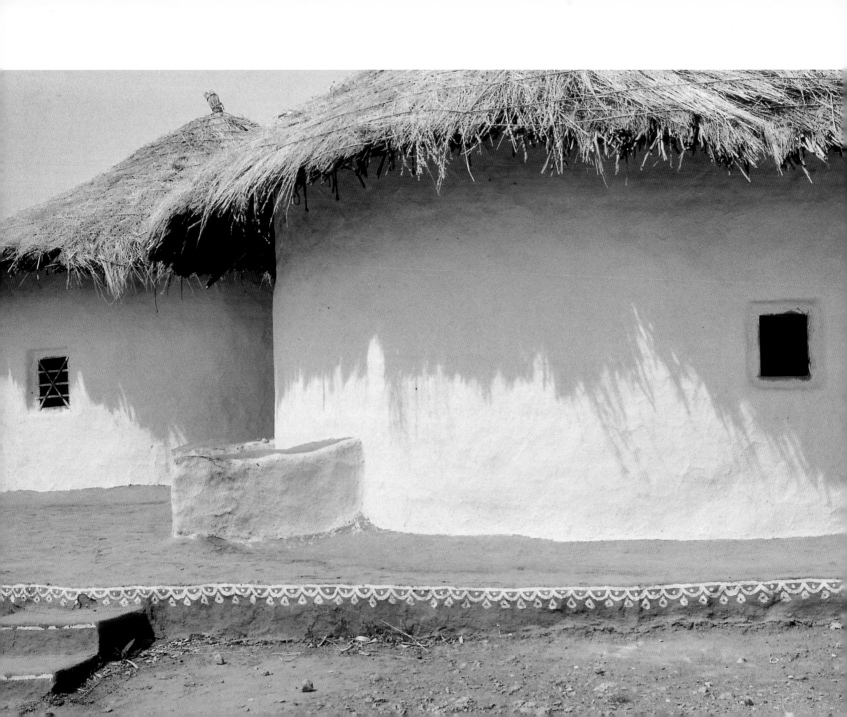

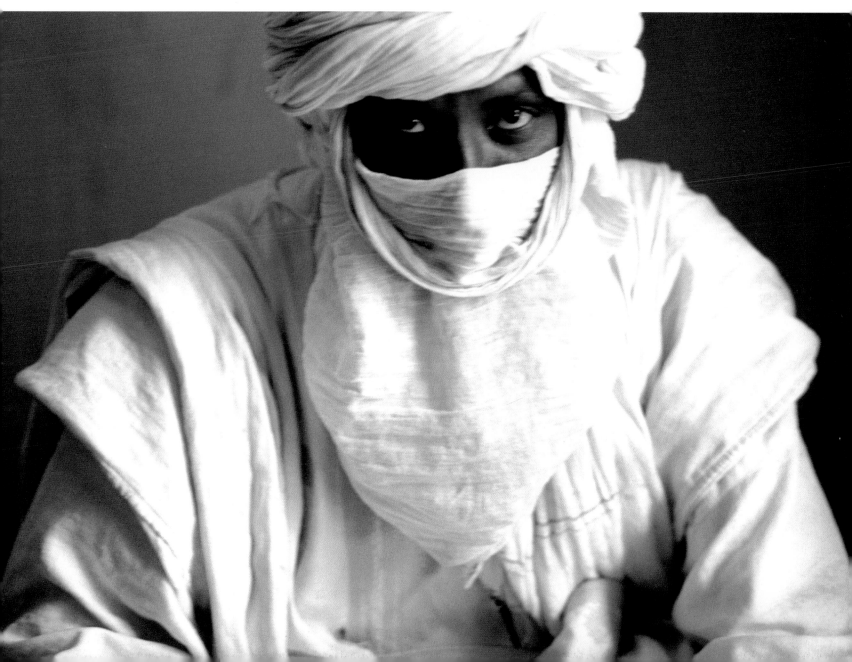

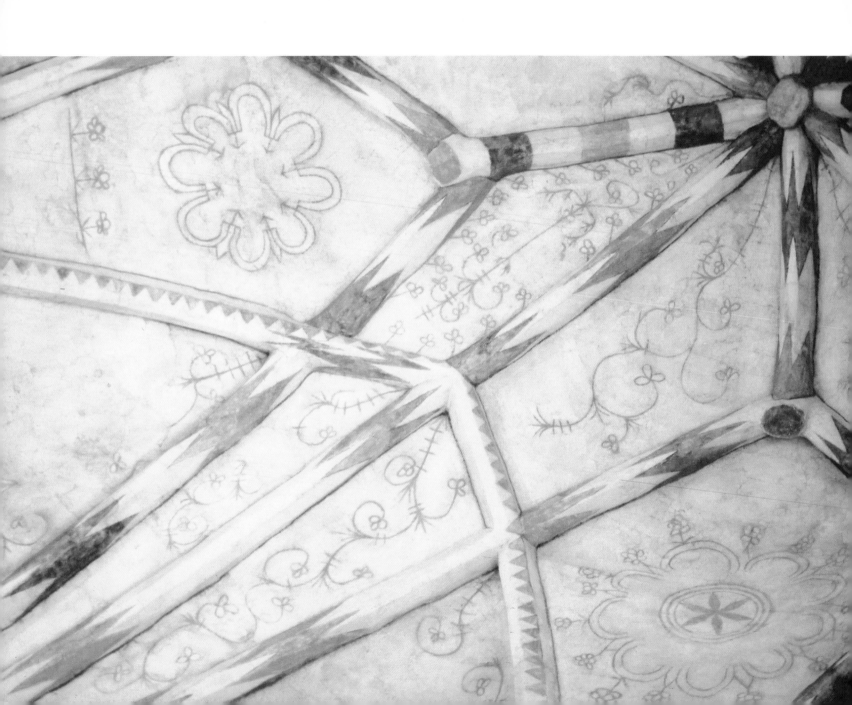

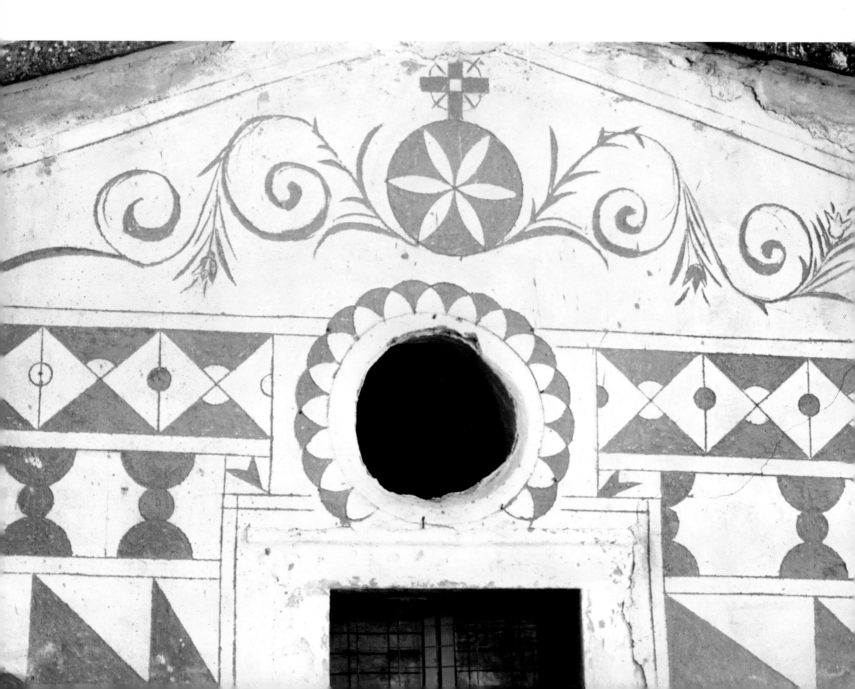

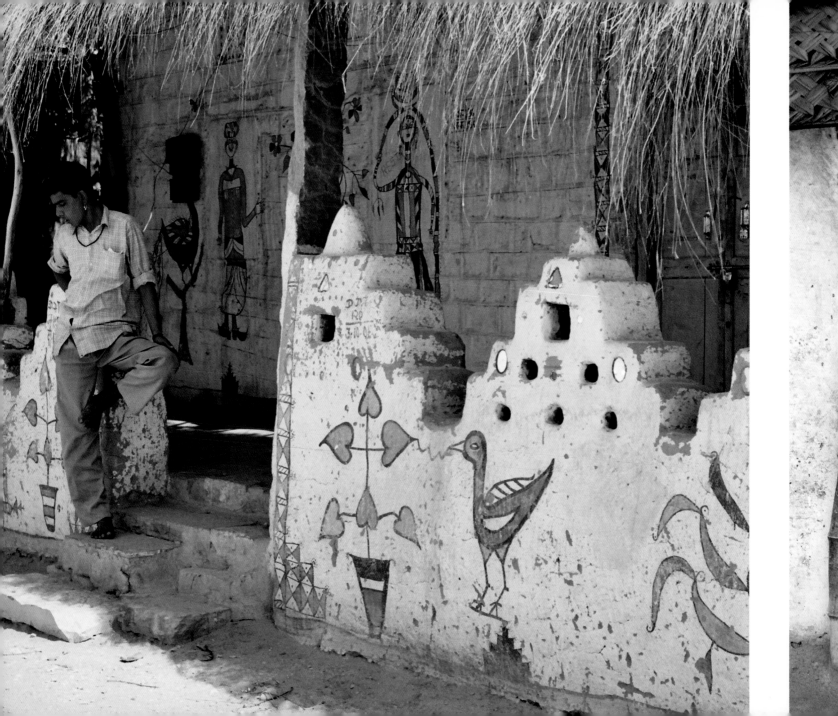

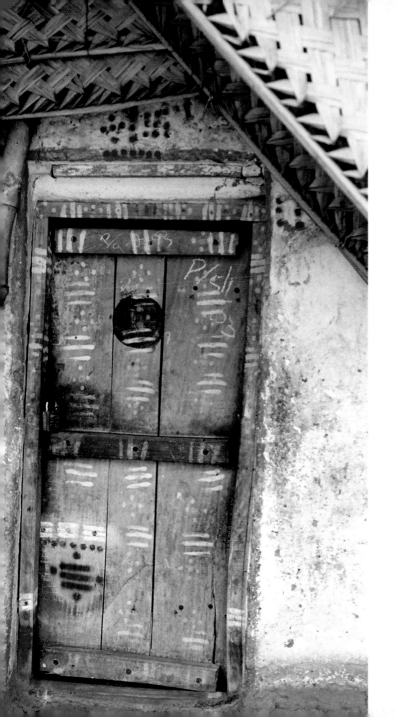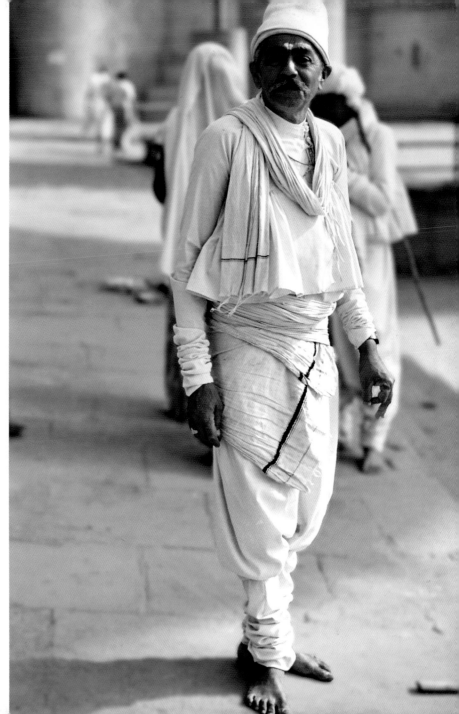

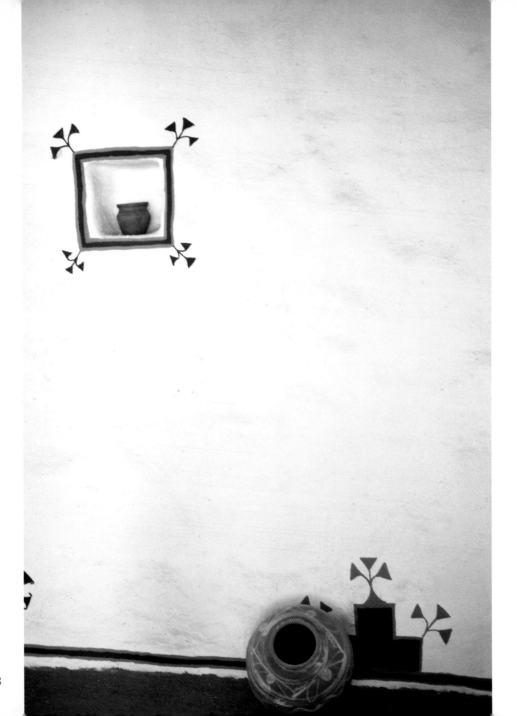

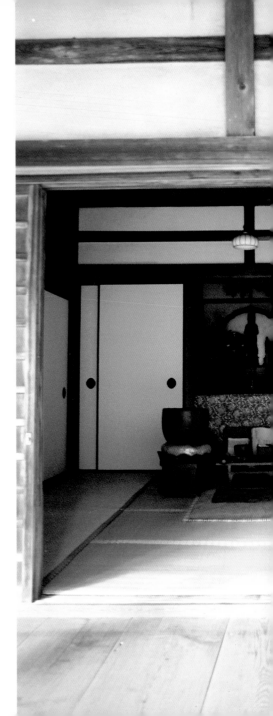

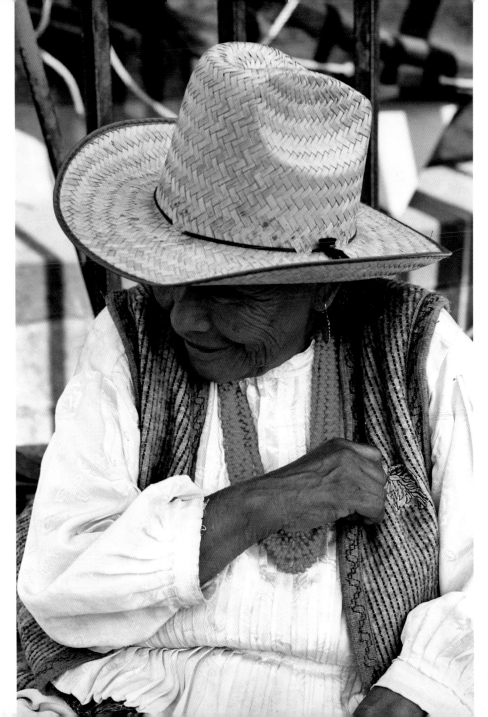

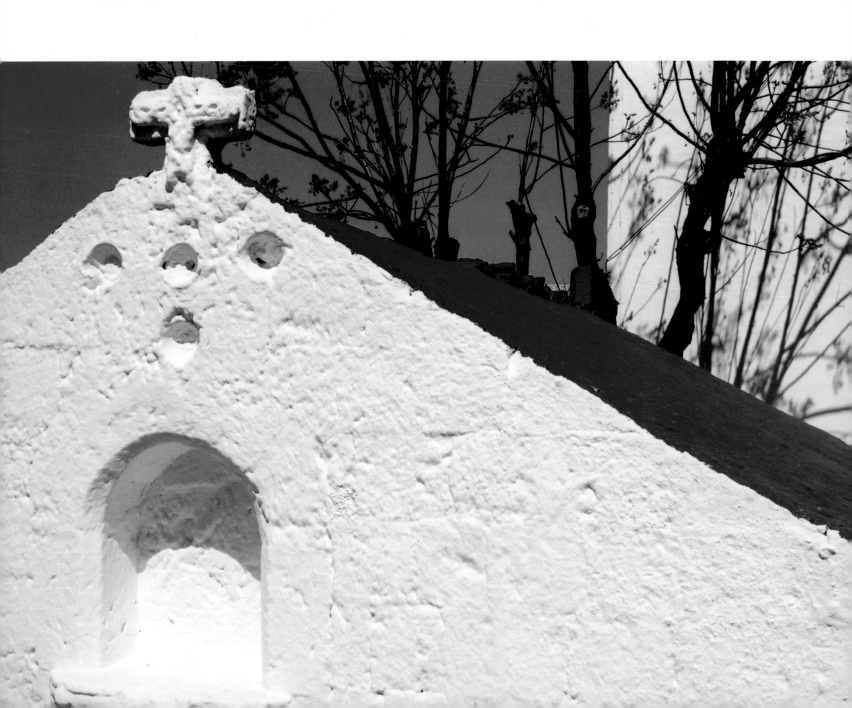

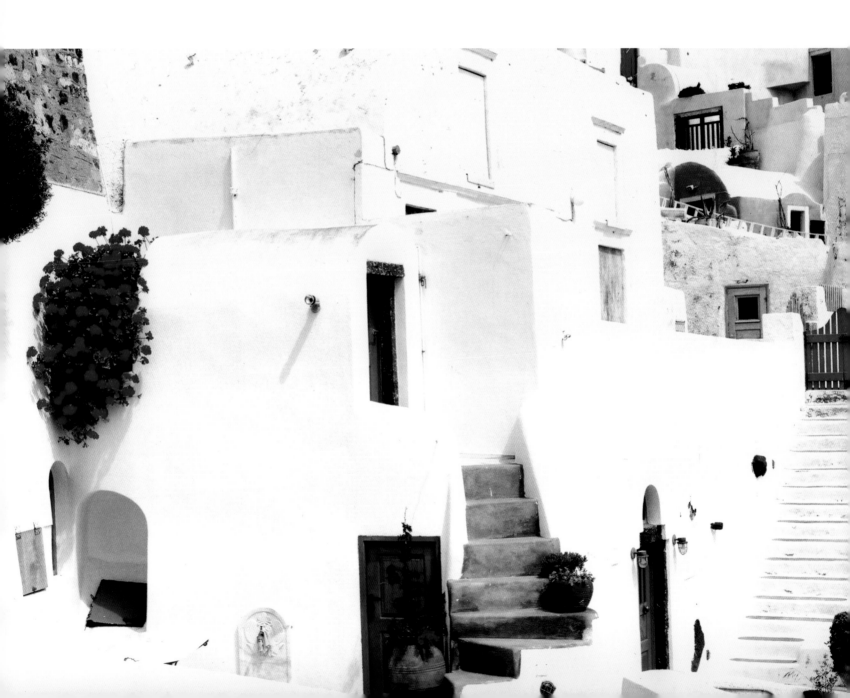

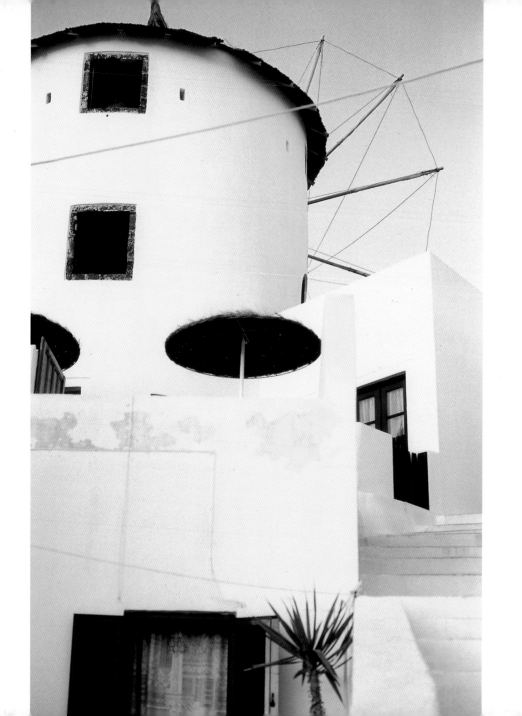

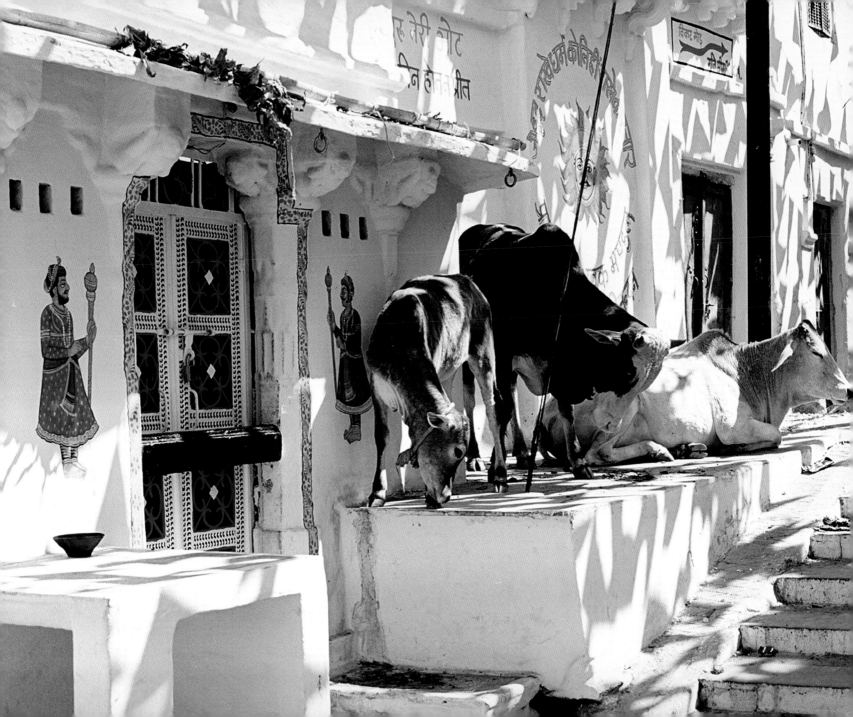

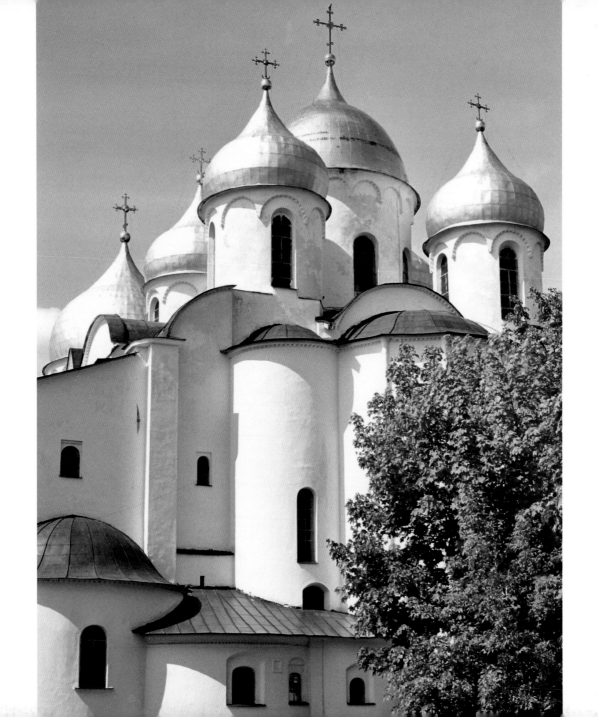

White is synonymous with light: sometimes the emblem of divinity, it is also the embodiment of humility, purity and innocence. These positive, virtually universal values have transcended time without ever losing any of their symbolic power.

In Christianity it is often said that God appears in a white light while angels are never imagined as wearing any other colour. In the Arab-Islamic world, white signifies loyalty and the absolute oneness of God: white is a colour beloved of Allah. In India, where white is associated with detachment and serenity, it is the colour of the highest caste, that of the Brahmins, or priests.

Because of its purity, white is the chosen colour of mourning in many parts of the world, notably in Asia and in some African countries. In the West, black only took on that role in the seventeenth

A white lie. White wine. White noise. A white elephant. White flag. A white wedding. One could see the whites of his eyes. A white-knuckle ride.

century: in the Middle Ages mourning clothes were made of rough, undyed cloth as a sign of penitence and humility.

In present day Japan, presents are wrapped in white paper to protect them from the dirt of the world. In Mediterranean countries, purifying whitewash is regularly spread over the walls of houses, and sometimes even on the doorstep.

In the Christian world, white, with its virginal connotations, did not replace the colour red for brides until the early nineteenth century and was seen to guarantee the purity and innocence of future generations. Brides in Japan traditionally wear a white kimono to symbolize their purity and their commitment to a new existence.

Show the white feather. The white rabbit. As white as snow. As white as a sheet. A white Christmas...

yellow

lemon yellow, canary yellow, buttercup yellow, chrome yellow, yellow ochre, saffron yellow, yellowed with age, golden memories, mellow yellow, daffodil yellow, mustard yellow...

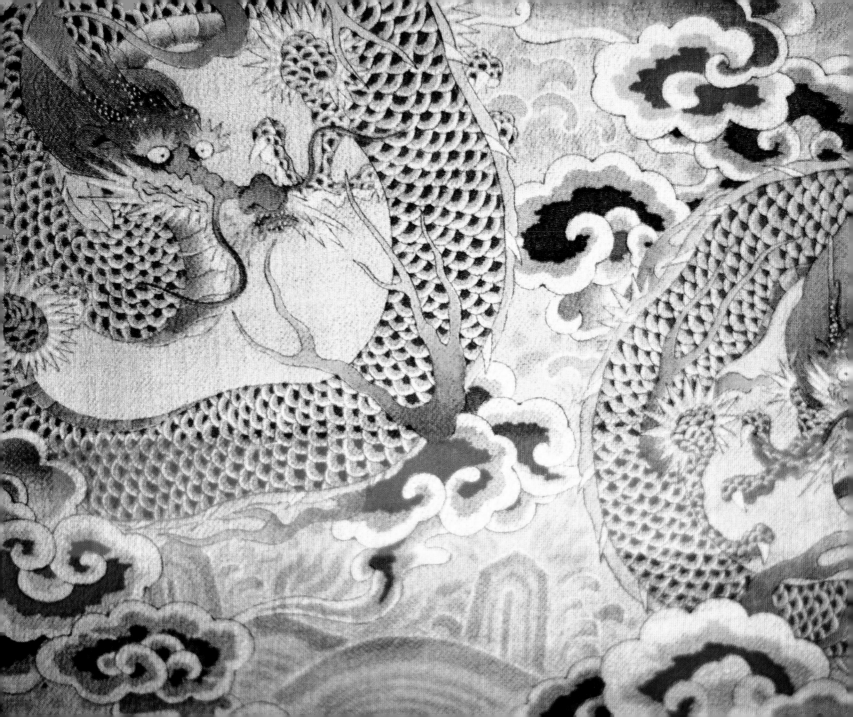

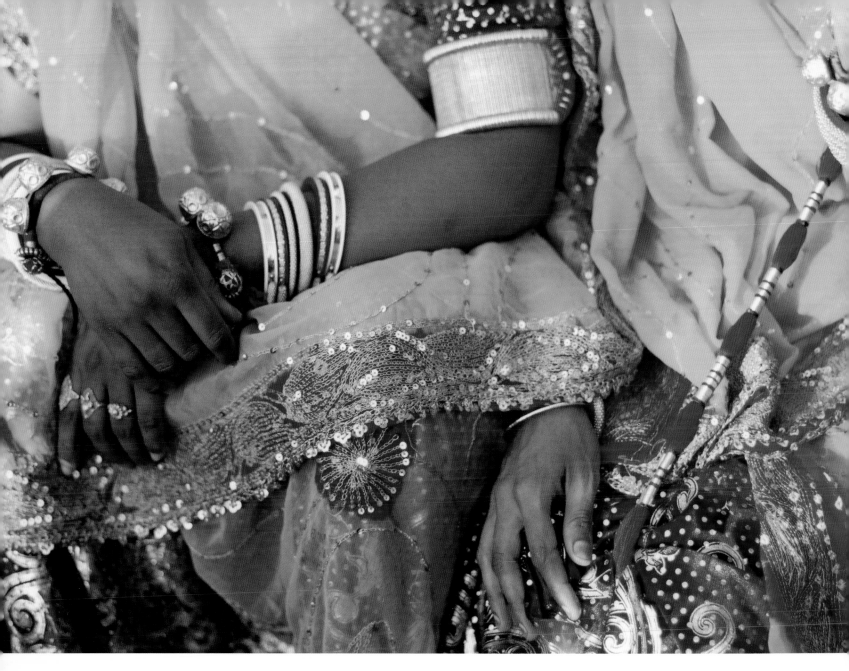

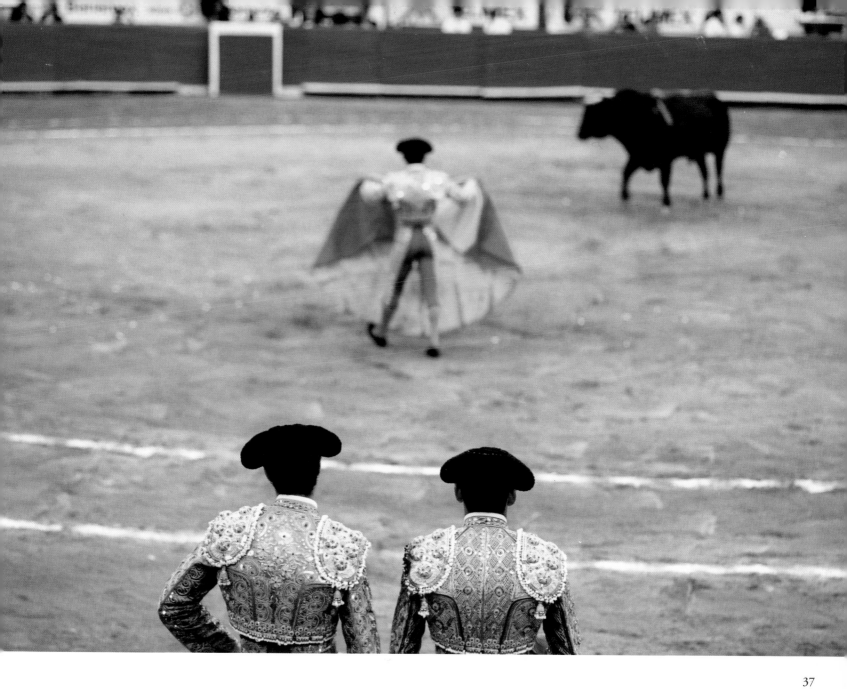

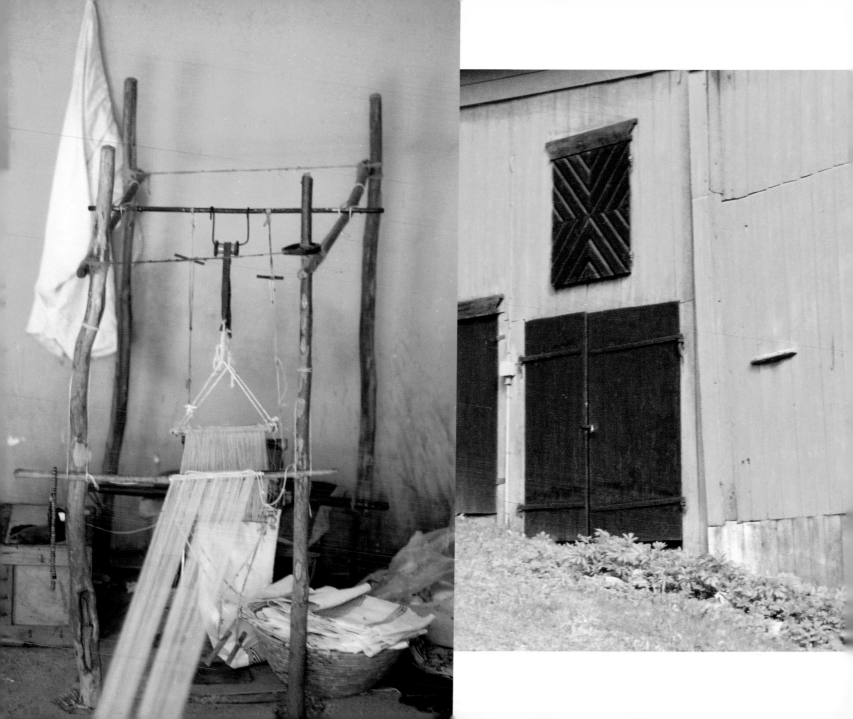

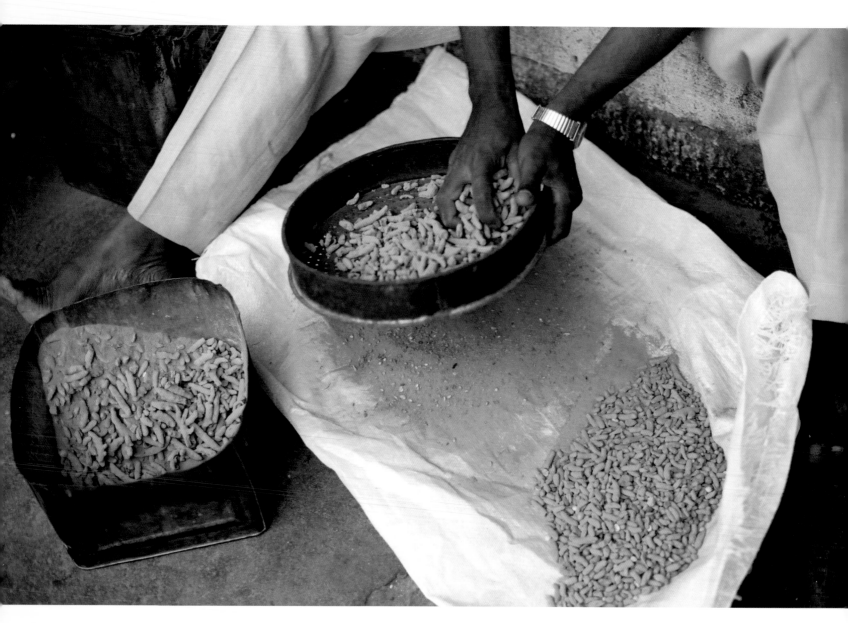

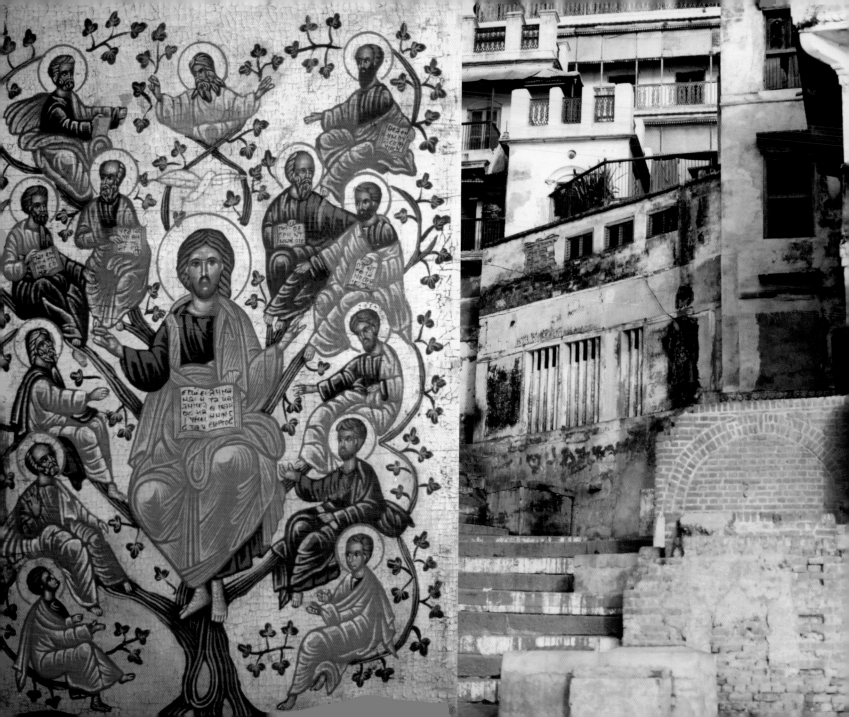

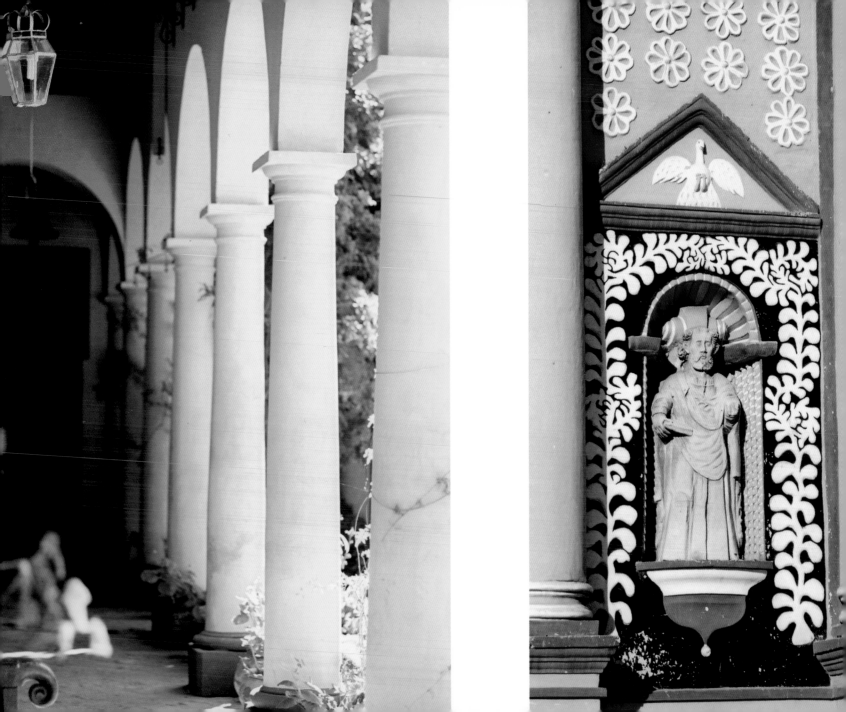

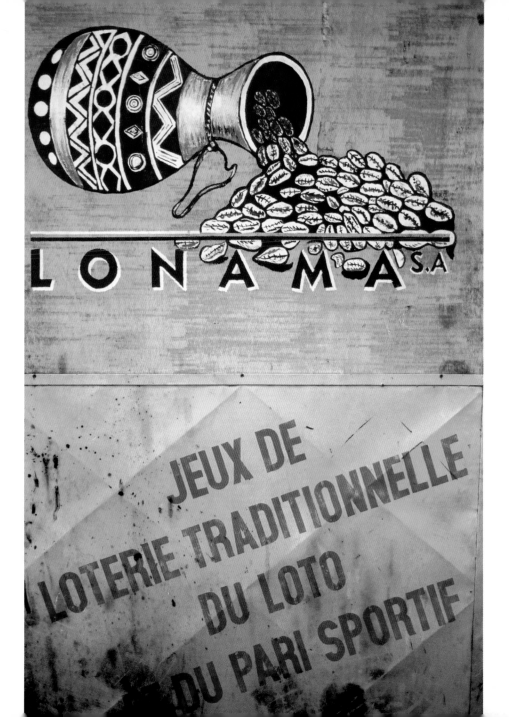

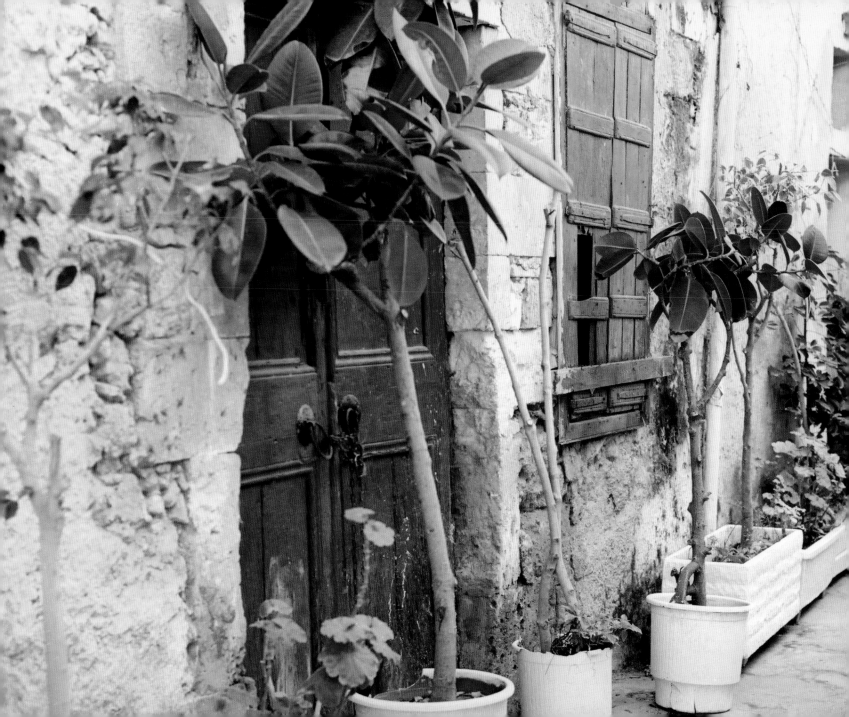

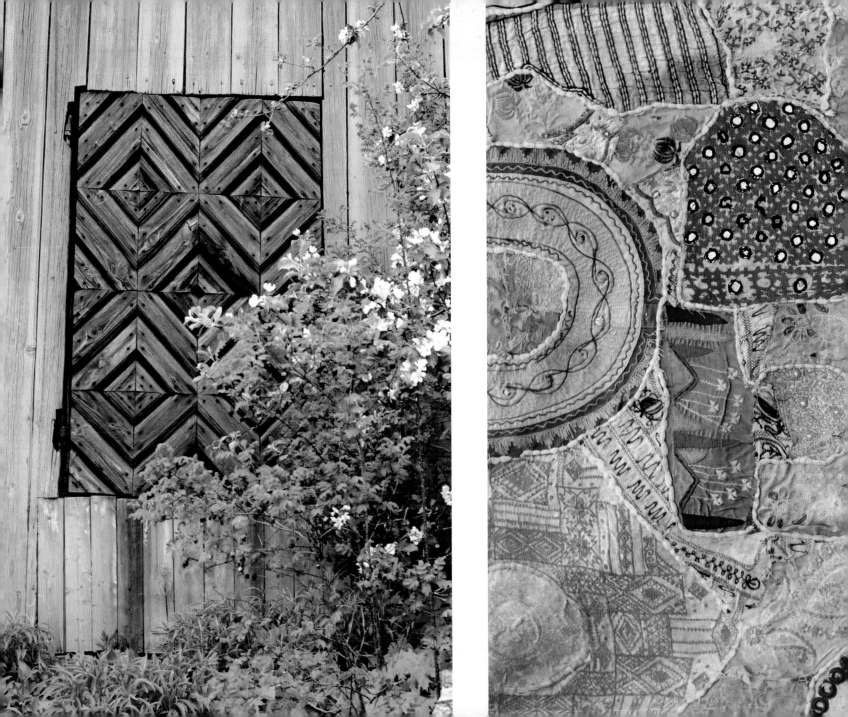

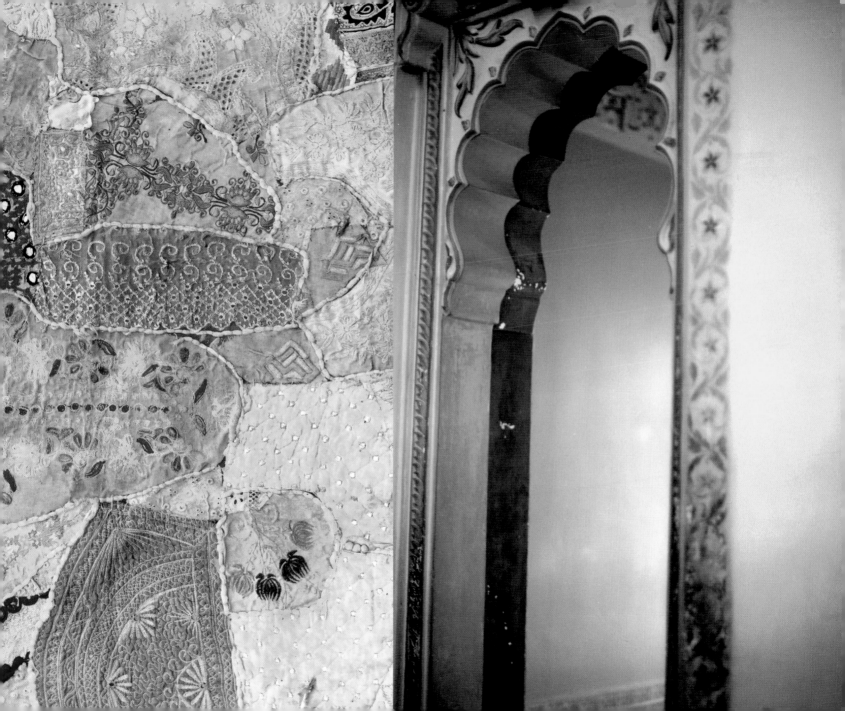

Across various cultures and at various times, yellow has sometimes been associated with power and wealth, and sometimes with exclusion and betrayal too.

In Western Europe in antiquity, yellow was associated with light, the sun, gold, and power. Roman women wore yellow as a sign of joy on ceremonial occasions and at marriages.

In India, yellow is the prevailing colour at weddings, where it is believed to ensure marital happiness, health, wealth, and fertility. It was also the colour worn by Rajput warriors in western India. Yellow is the sign of strength and virility.

In China, yellow is the colour of honour, and is the symbol of the earth. Only the emperor and royal princes were allowed to use it for their clothing and for the tiles that covered their palaces. It brought

Yellow fever. Follow the yellow brick road. Yellow-bellied. Yellow metal. A yellow card. The yellow pencil. Yellow press. Yellow peril. Yellow jersey.

good luck, and stood for power, glory and wisdom. It is still the favourite colour of the Chinese and of Hindus too.

In the West, the slow devaluation of yellow began in the Middle Ages. Until then, its association with gold had conferred upon it connotations of both light and richness. Little by little however, it was stripped of its qualities until it became the colour of autumnal decay and of illness. From there, it was not long until it became the symbol of treason and deceit: yellow was the colour of husbands whose wives were unfaithful, and the houses of counterfeiters were painted yellow to draw public contempt. Throughout Western Europe, yellow was also seen as Judas' colour.

This dislike of yellow in the West gradually faded during the Empire period in France, when its luminous and lively qualities and its warm tonality were prized in interior decoration.

Yellow hammer. Yellow fin. Golden anniversary. A jaundiced view. Double yellow line...

green

emerald green, jade green, jungle green, sage green, olive green, bottle green, pea green, sea green, acid green, apple green, leafy green, lime green, imperial green, pistachio green, forest green, grass green...

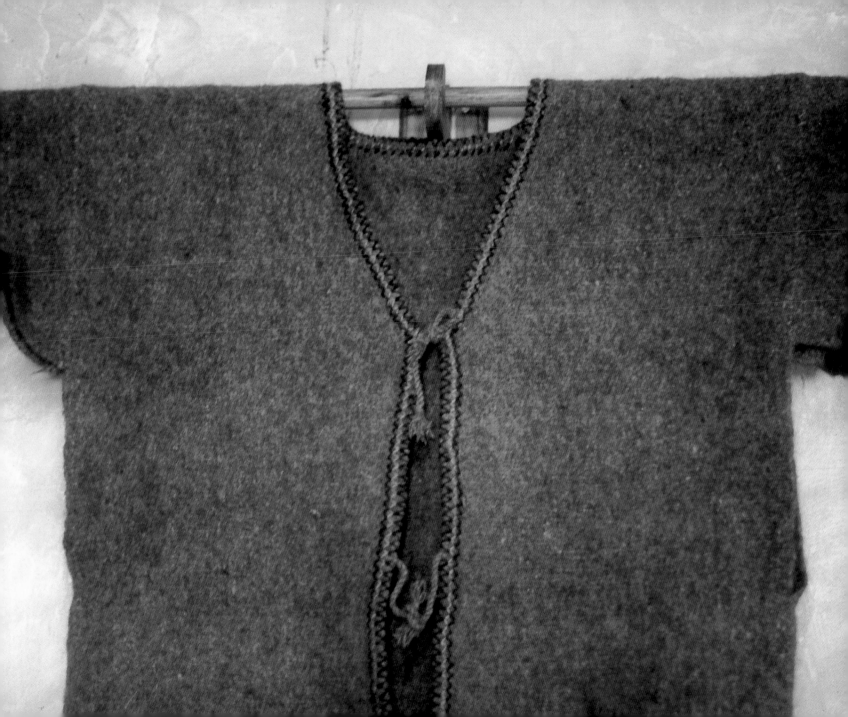

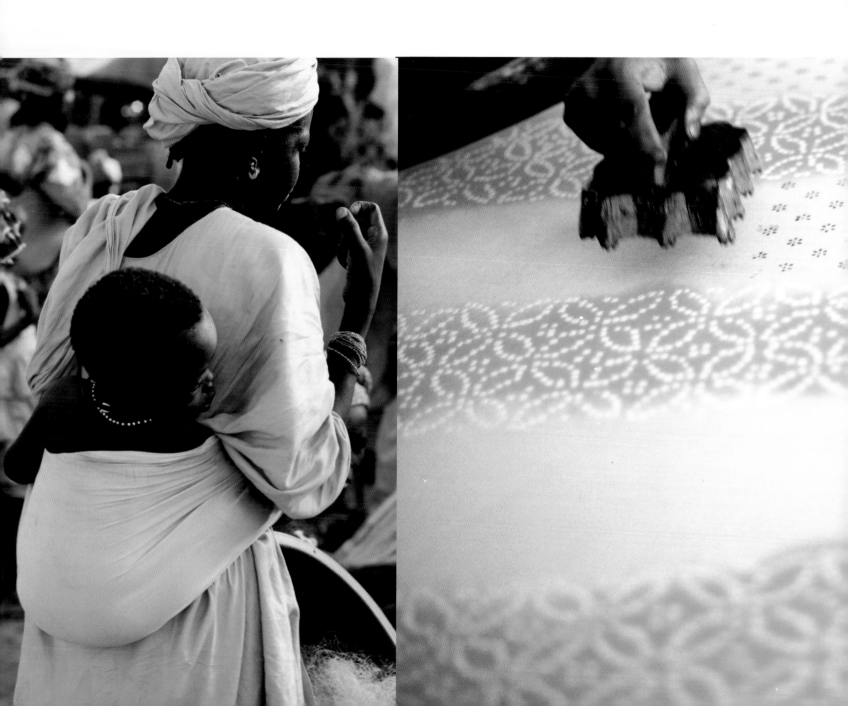

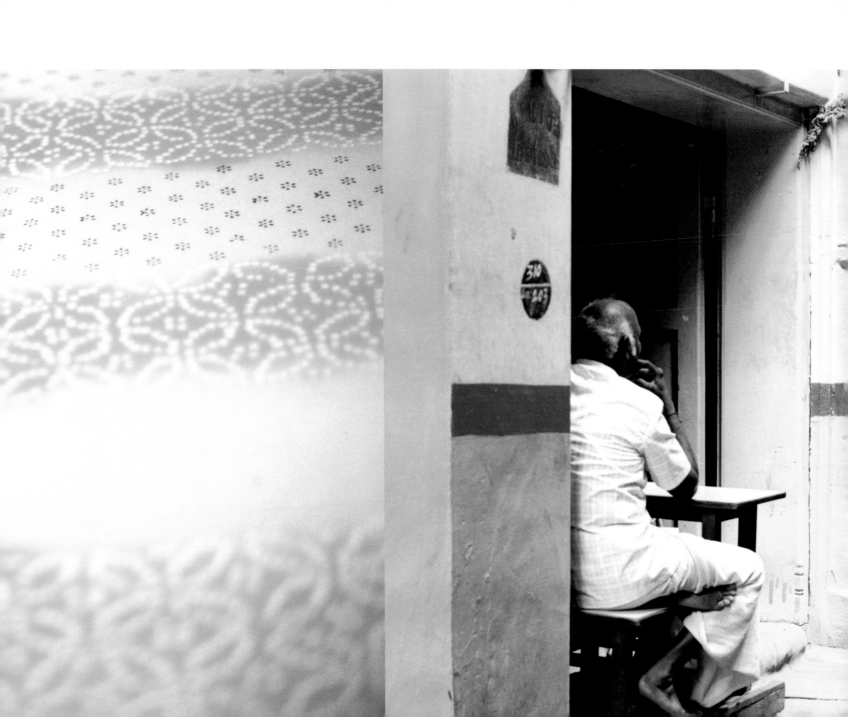

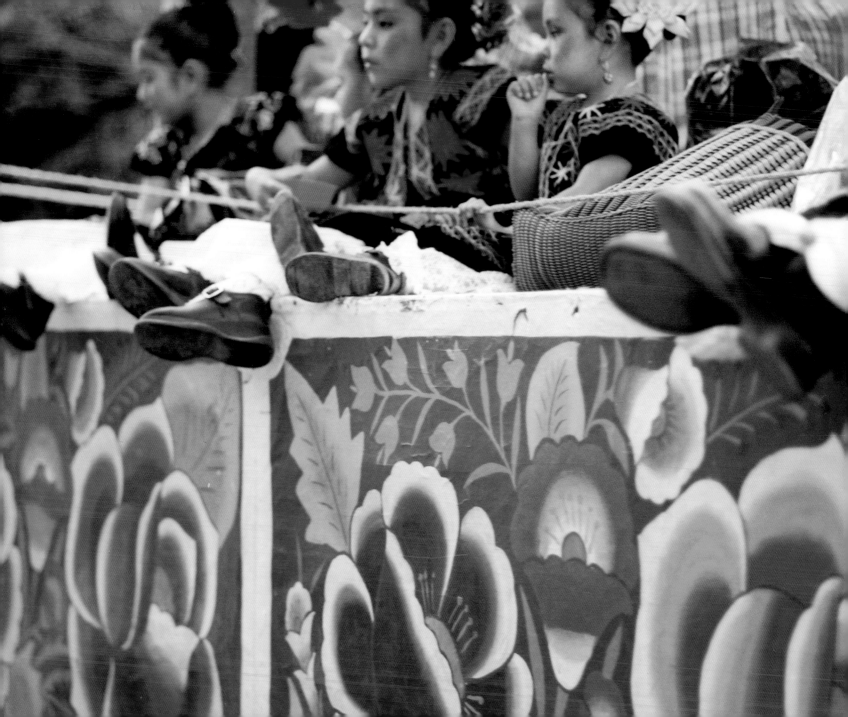

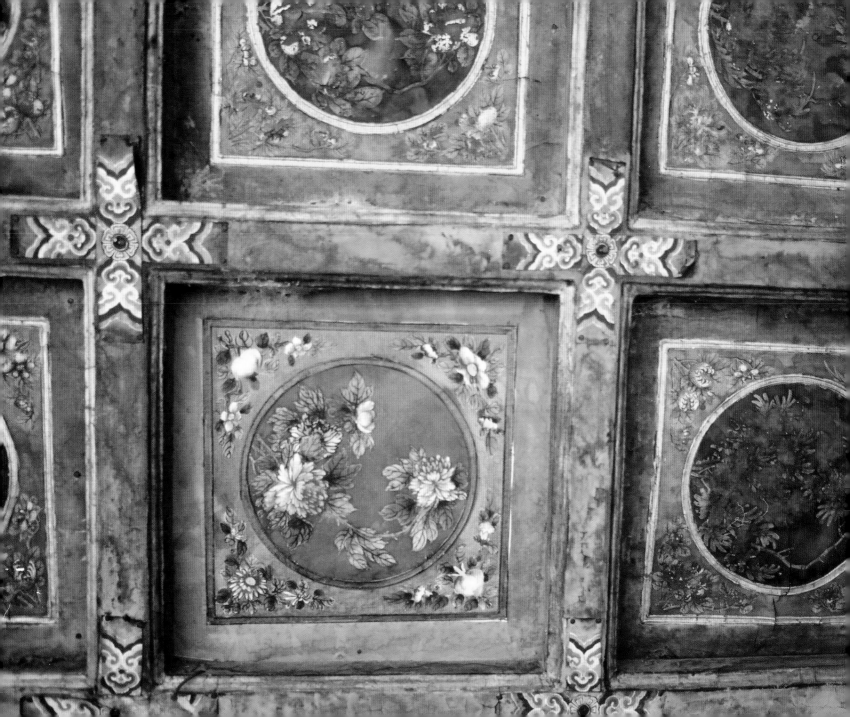

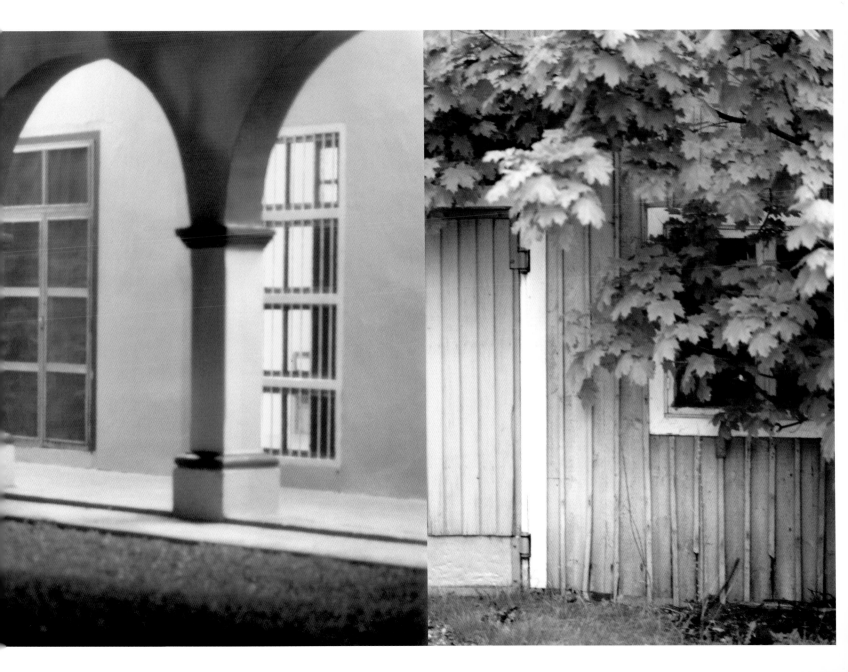

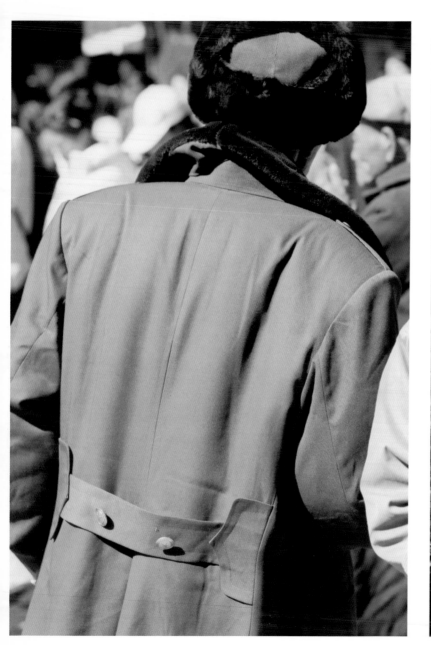

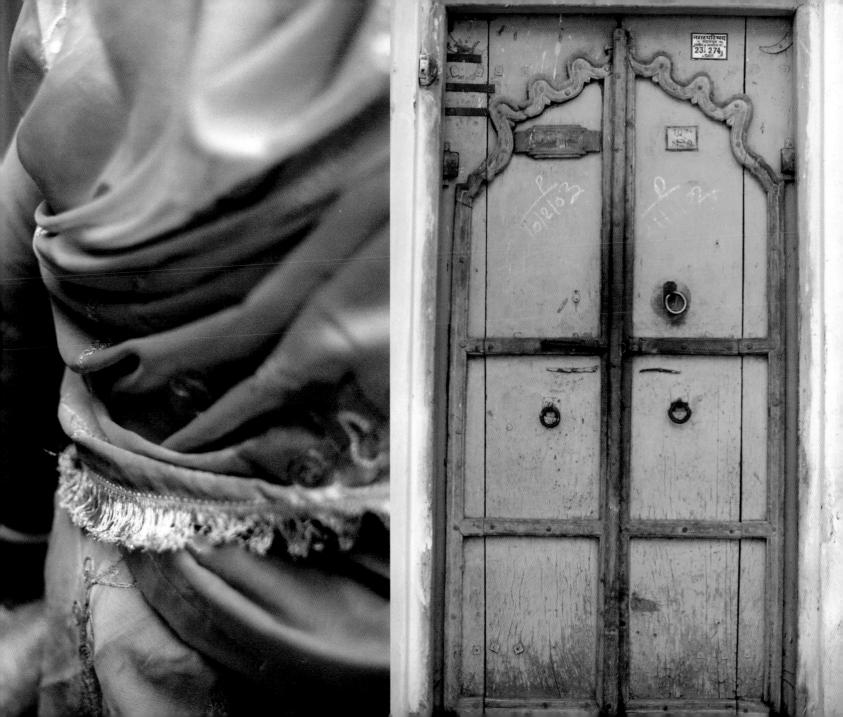

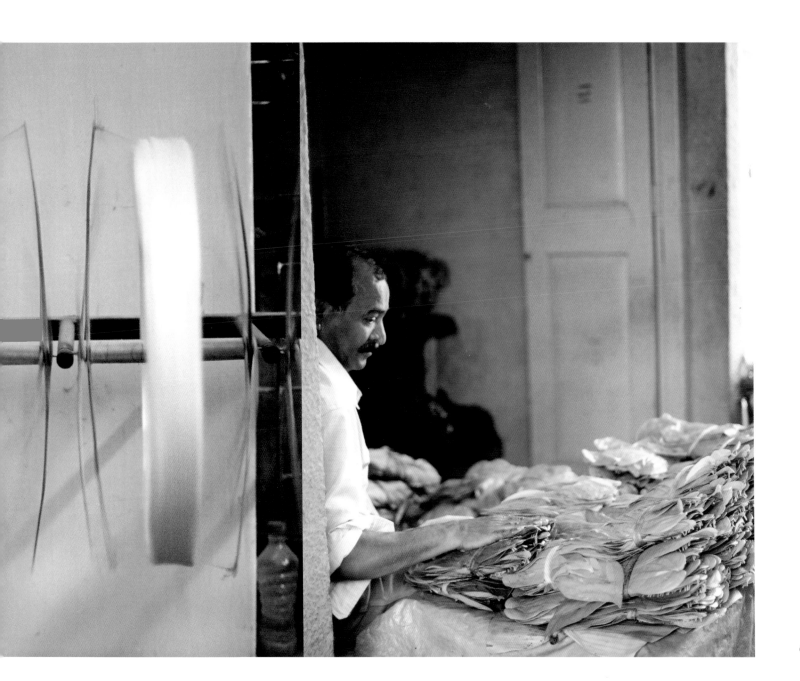

Green has not always been thought of as the colour of nature, especially not in the West. None of the four elements – earth, air, fire or water – suggest the colour green. Its association with nature probably goes back to the time of Muhammad, when all green land was thought of as paradise. In classical Arabic, the words for 'green', 'vegetation', and 'paradise' all have the same root. This strong, and very positive symbolism still prevails in modern Islamic culture, where green is the colour of material and spiritual richness: pilgrims returning from Mecca wear green turbans. Green, with its connotations of fertility, joy and balance, is the most highly prized colour, above black or white, in Islamic countries today.

In the Christian West, on the other hand, the colour green has very different associations that are far from paradisial and tell a very different story.

The unimportance of this colour in early times is evident from the fact that in Latin there is no word to distinguish green from blue. Green seems to have been long associated with instability, probably because dyers found it such a difficult colour to fix. Even now, green tends to suggest the changeable

Green fingers. Green with envy. Little green man. Green-eyed monster. Green back. Greenroom. Get the green-light. Green card. Greengrocer.

nature of things: not by accident is it the colour chosen to cover gaming tables. Instability is only a step away from disorder and madness, and up until the end of the Middle Ages, the insane were dressed in green.

That arsenic was used throughout the centuries to produce the colour green probably led to its sinister reputation: wet green cloth in contact with the skin could prove fatal. Even now, there is a superstition among actors that you should never wear green on stage.

Finally, when Newton discovered the spectrum in the eighteenth century, leading to a new classification of colours, it was realized that green could be made by combining blue and yellow. Dyers were at last able to produce true greens. The colour began to be associated with nature and with spring, and eventually, to be seen as synonymous with fertility and rebirth. Today, green is the colour of growth, freshness and youth, and is used to suggest good health and freedom. Green 'permits' what its complementary colour, red, 'forbids'. This calm and restful colour is now second only to blue in popularity in the West.

Green tea. Green house. Greengage. Green belt. Greenhorn. A green old age...

blue

sea blue, electric blue, baby blue, navy blue, sky blue, petrol blue, prussian blue, cobalt blue, aquamarine, royal blue, turquoise, sapphire, powder blue, duck-egg blue, midnight blue, blue-black, cornflower blue...

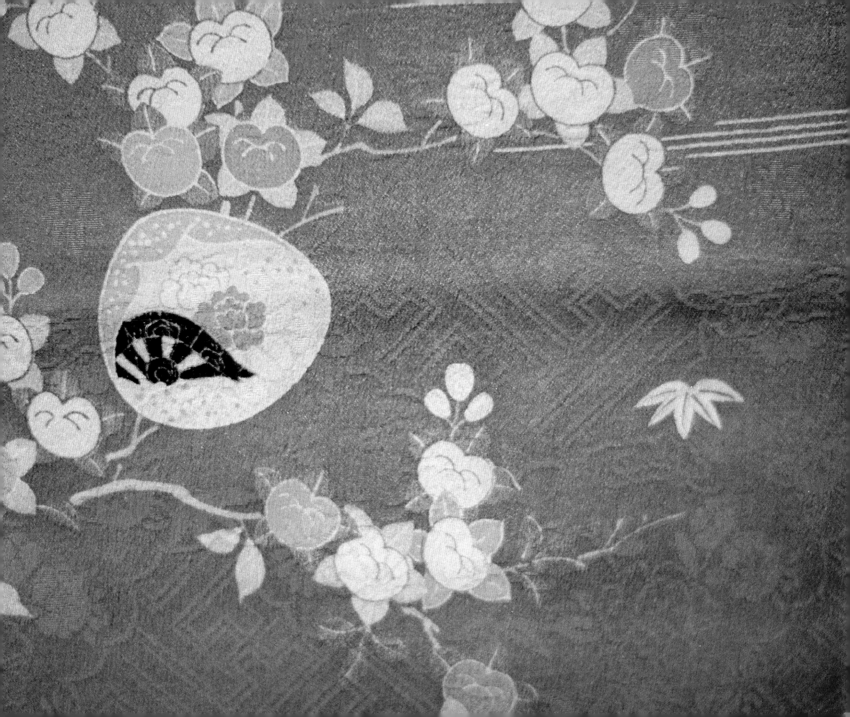

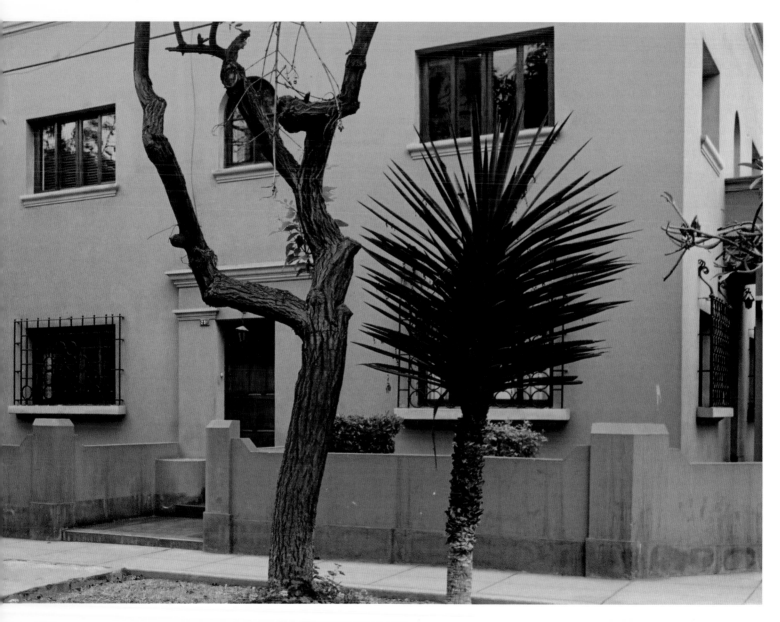

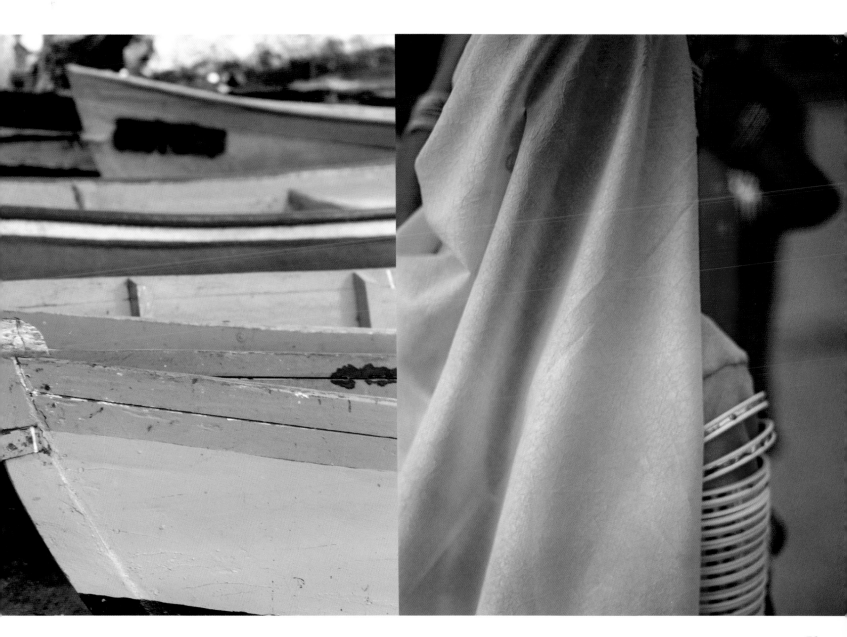

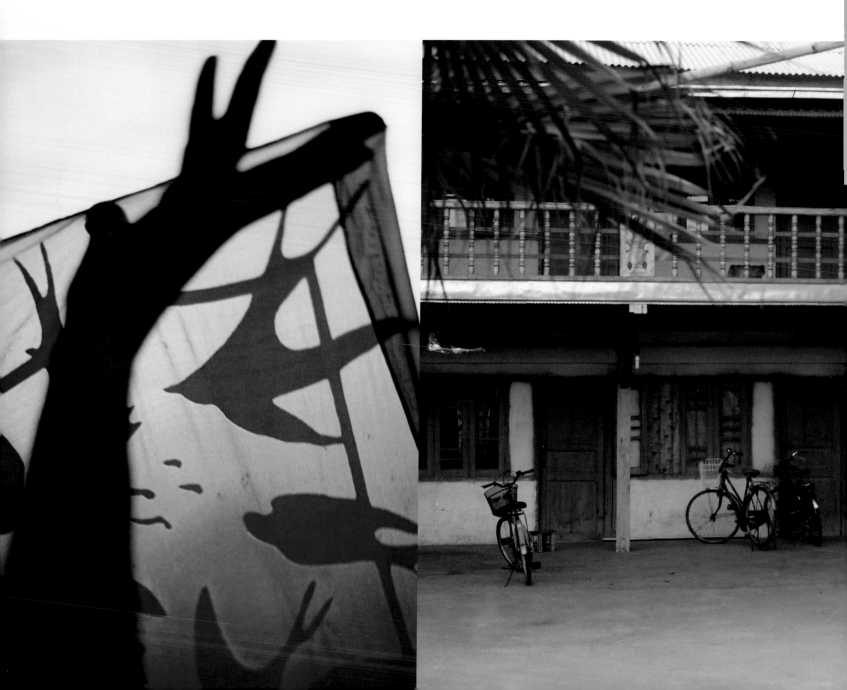

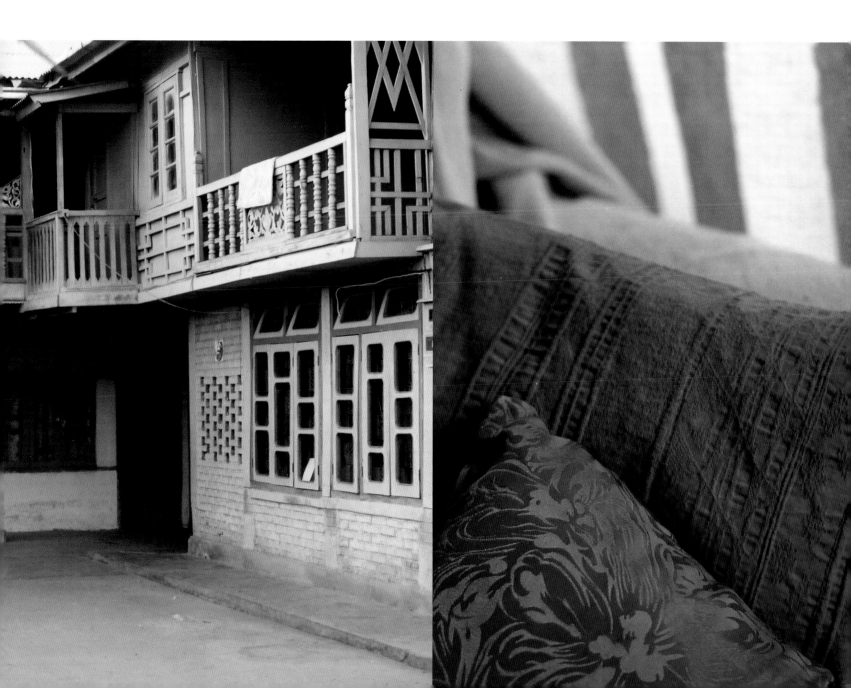

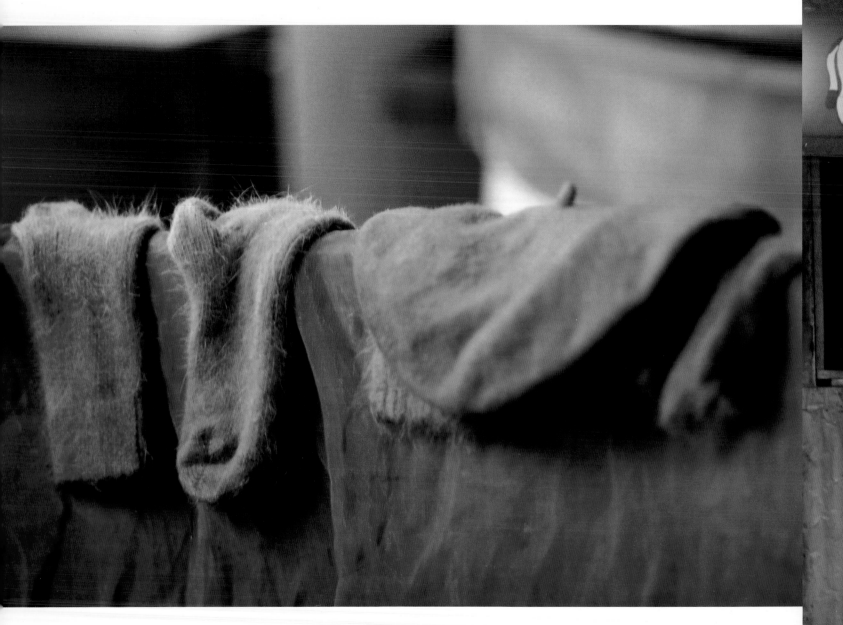

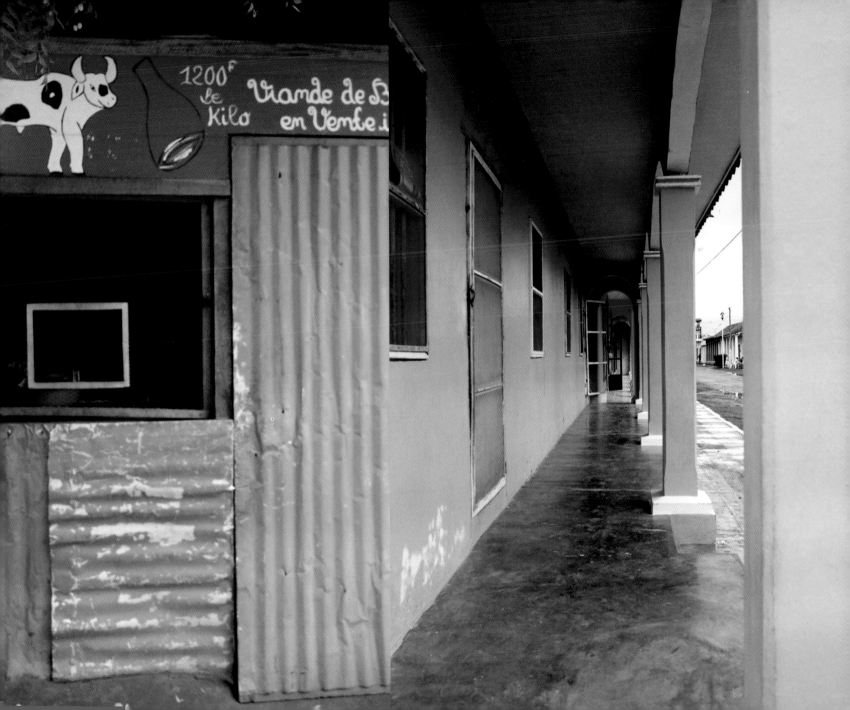

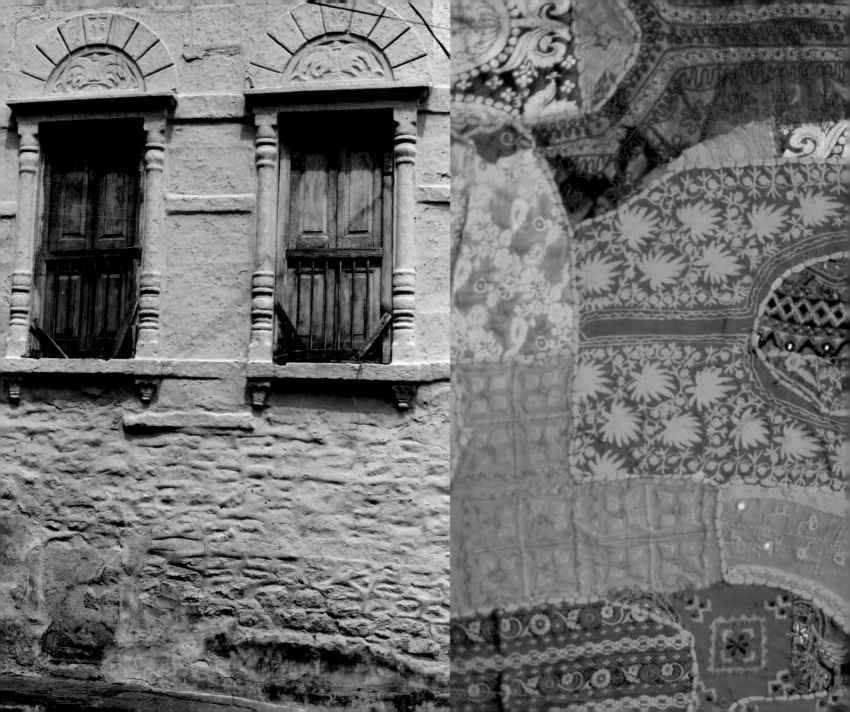

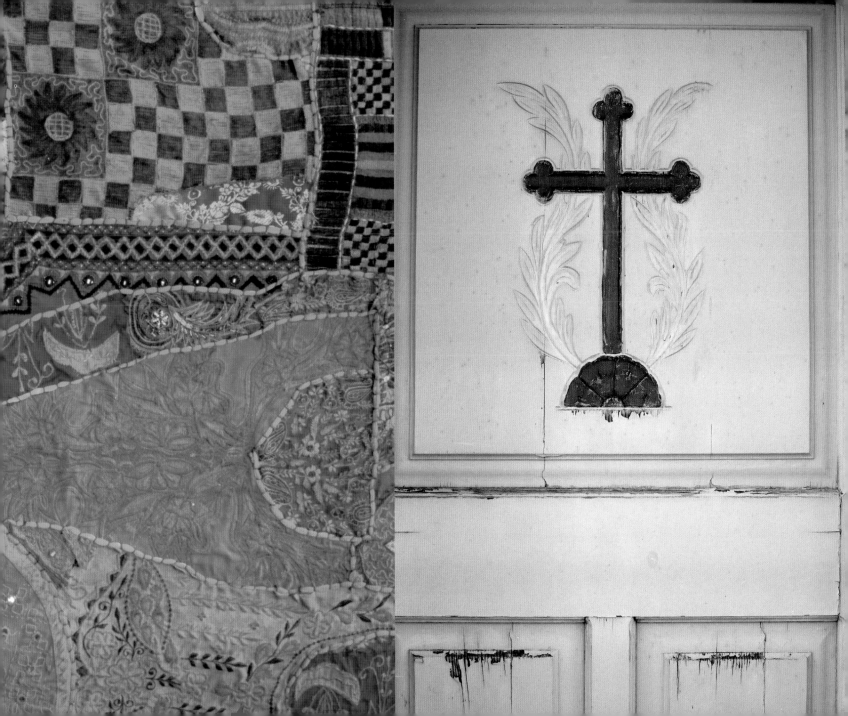

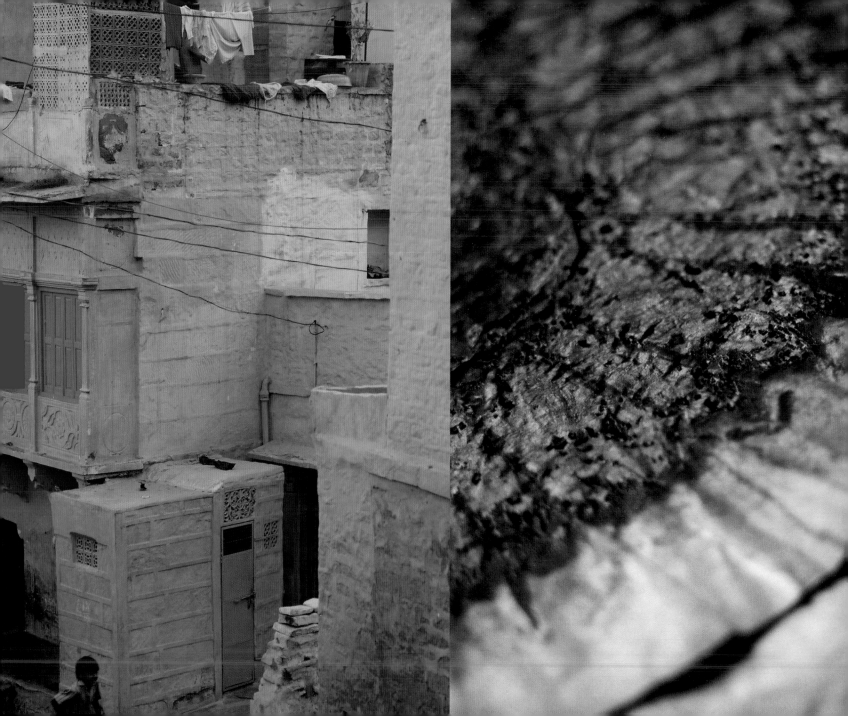

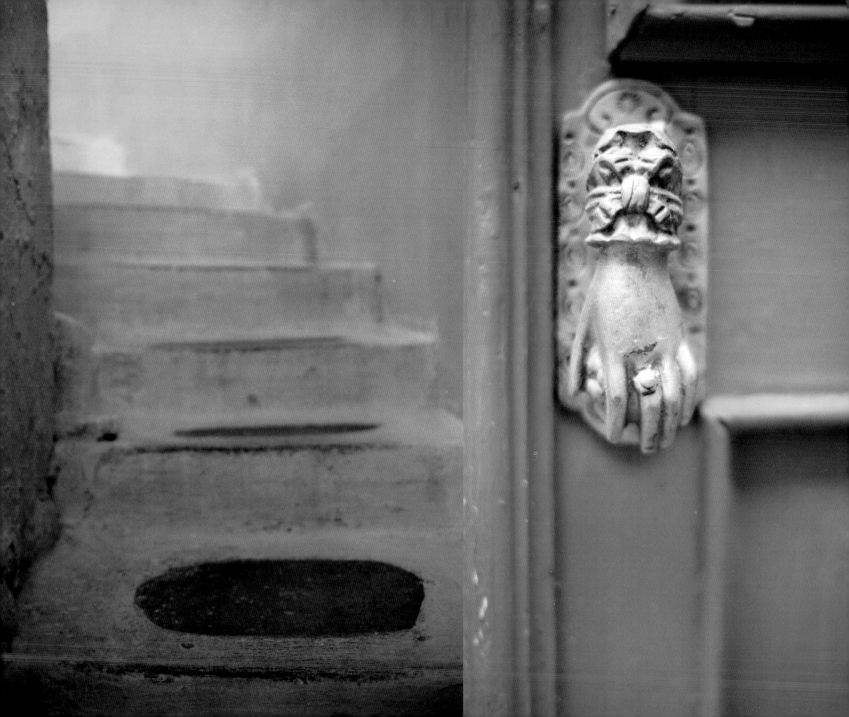

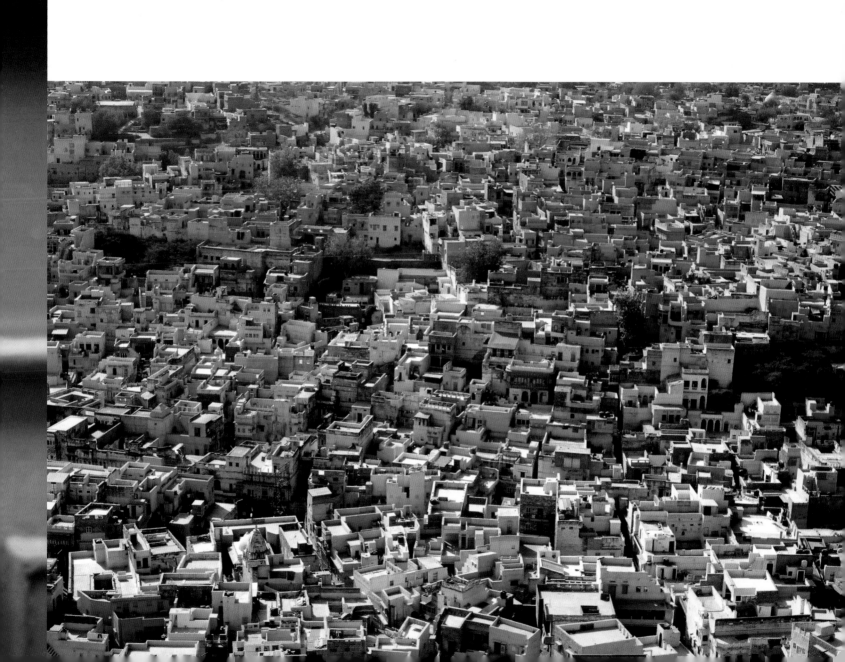

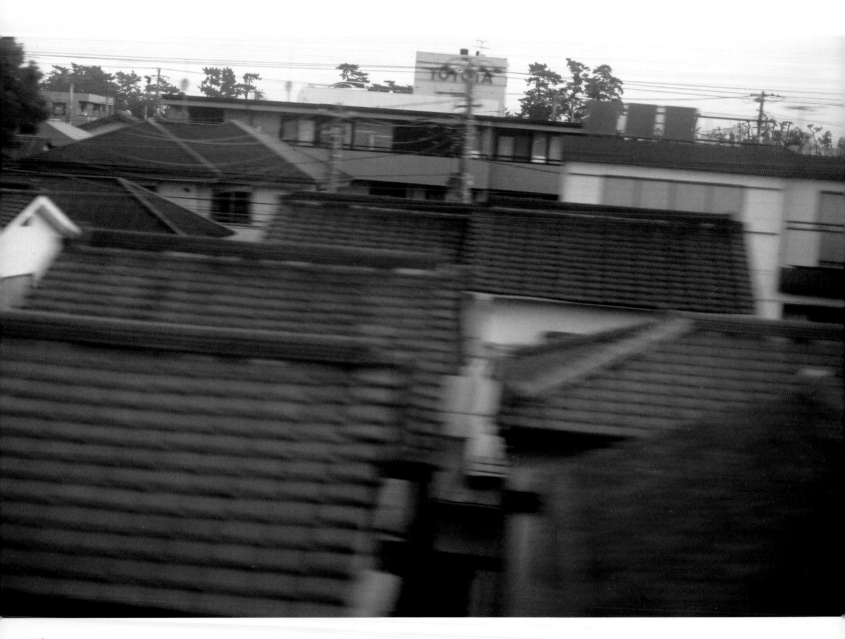

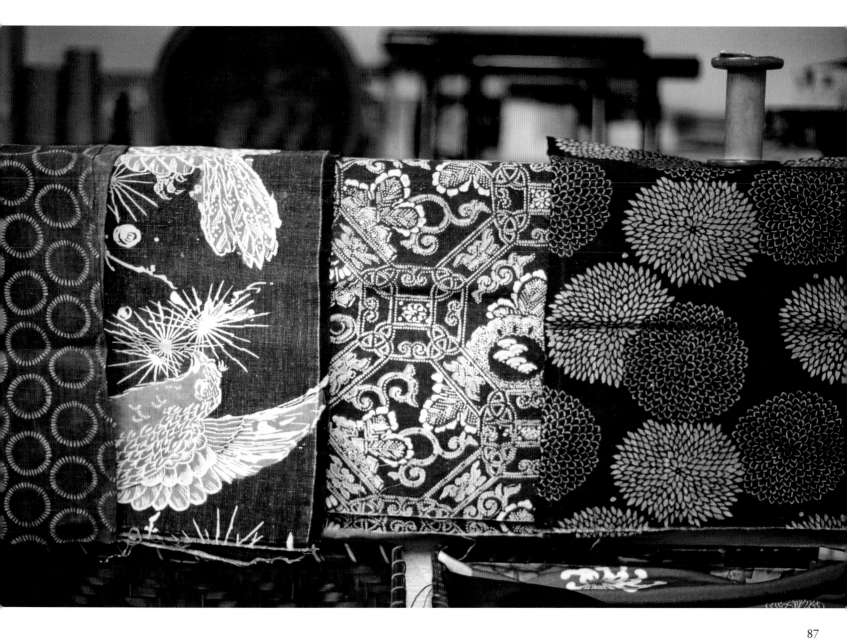

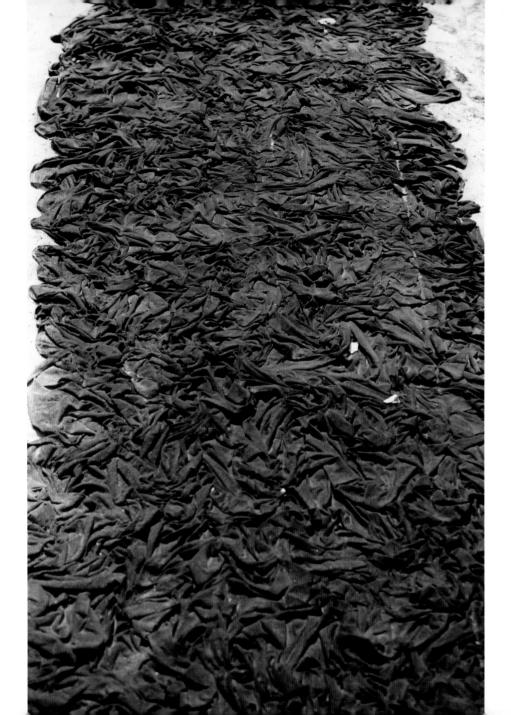

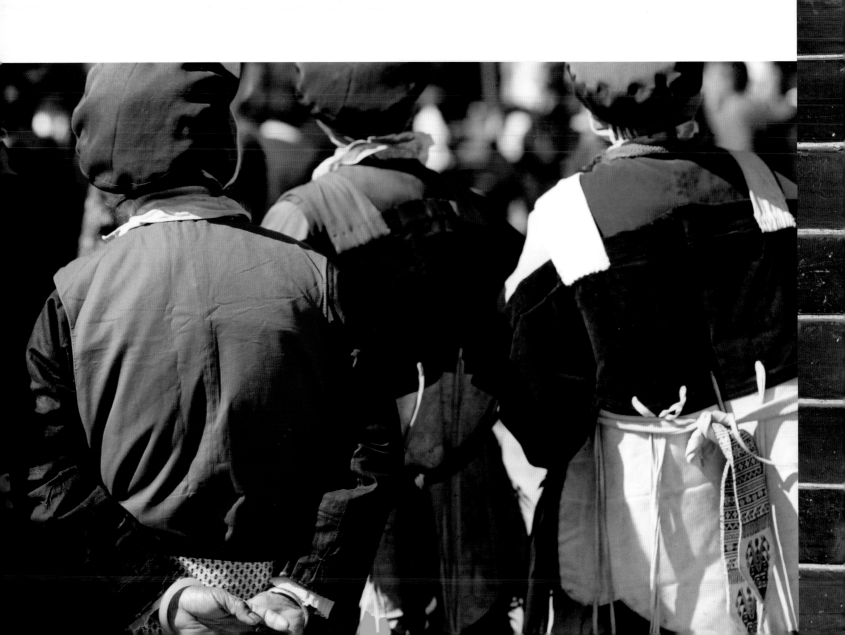

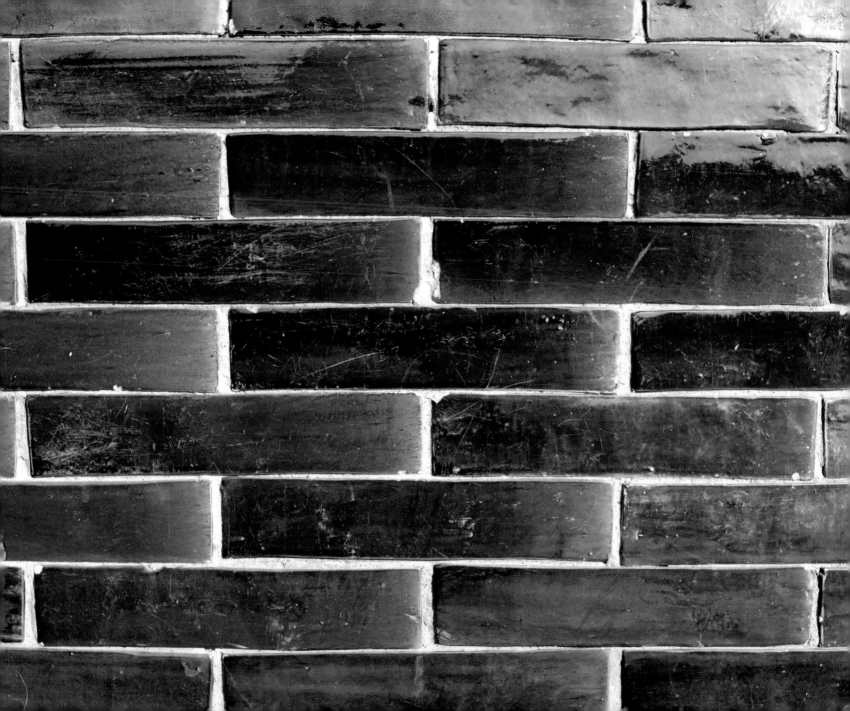

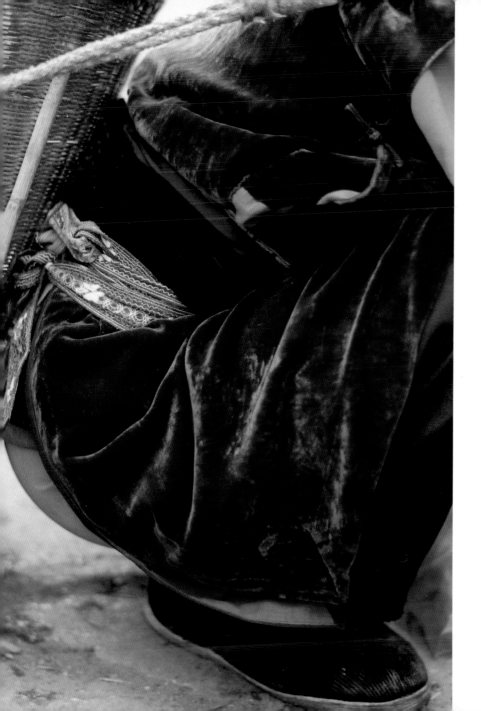

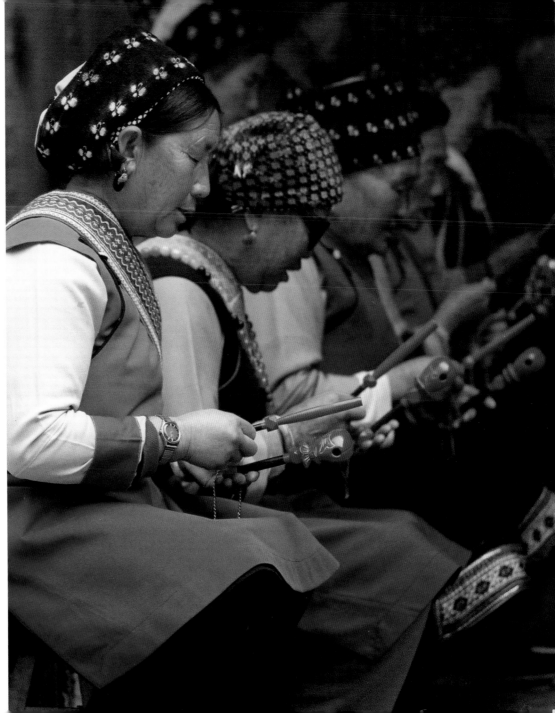

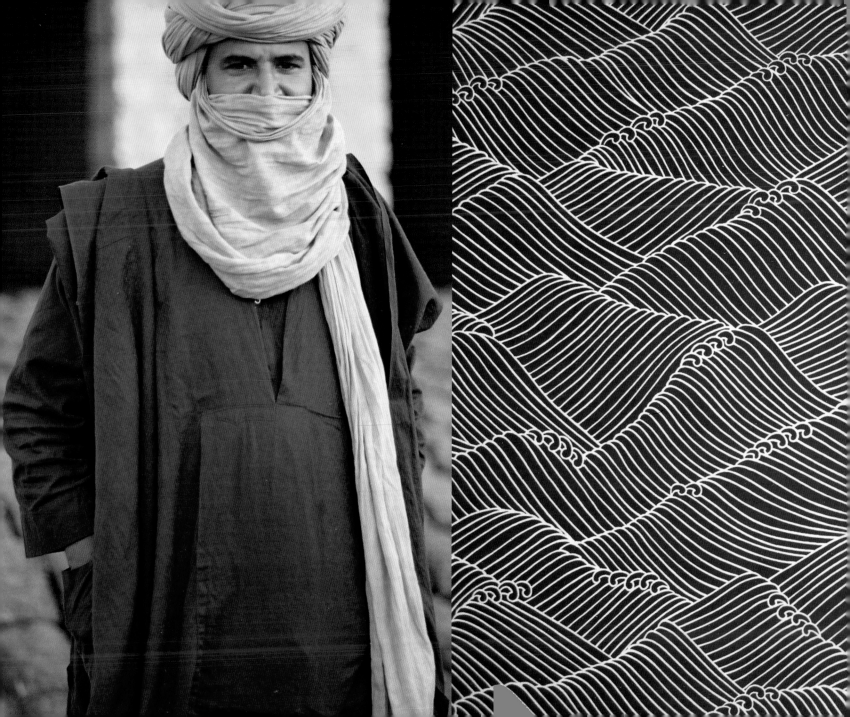

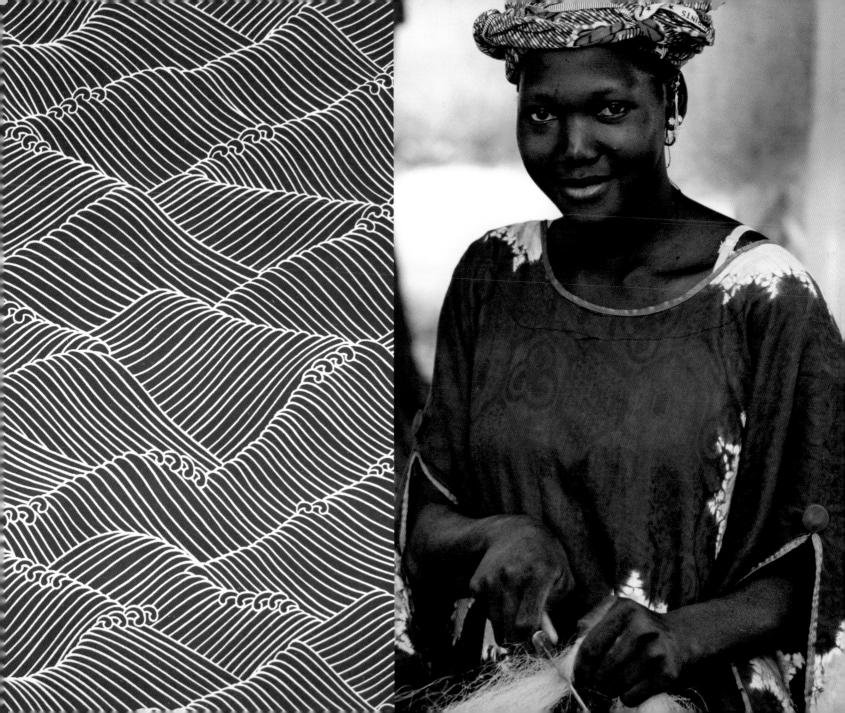

Blue is often cited as the colour Westerners favour above all, but that has not always been the case: barbarians painted their bodies blue in the time of the Roman Empire to appear ghostlike and thus frighten their enemies.

In India, blue is thought to bring bad luck and is associated with mourning: no wife whose husband was alive would dare to wear a blue sari. In its darker tones, however, it is the colour of erotic passion. Krishna, the god of love, is always depicted as being blue.

Blue was traditionally associated with pain in China. However, Mao introduced the fashion for blue work clothes, and the massive demand for blue cloth subsequently led to the development of synthetic indigo.

In Japan, the introduction of cotton and indigo at the end of the thirteenth century revolutionized rural life. The new cloth was light, warm and comfortable, and could easily be dyed locally. The Japanese slept under mosquito nets dyed blue, a colour soothing in itself, and which was believed to repel insects and snakes.

Blue blood. Blue-collar. Blue-eyed boy. Screaming blue murder. Blueprint. Blue-stocking. Blue in the face. Singing the blues. To have the blues.

In the Christian West, blue began to emerge from the shadows in the early twelfth century. Painters seem to have given up red, green and black in favour of blue, and the Virgin Mary, with her blue mantel, was the greatest ambassadress of this colour. Gradually, blue came to represent the colour of heaven and from the early fifteenth century onwards its popularity soared: kings and aristocrats dared to wear the colour themselves, and it became the sign of the very highest social class, that of the royal court.

In France, from the fourteenth to the sixteenth century, the blue produced from the woad flower was called 'blue gold', because it was sold by weight for the same price as gold. However, all that was to change with the mass introduction of indigo in the eighteenth century. It too was a vegetable dye – from the indigo plant – but it was cheaper (especially indigo from America and the Antilles), easier to use, and produced stronger shades of blue.

Blue is today prized for its soothing and harmonious character and is now the favourite colour of the majority of the planet's inhabitants.

Once in a blue moon. Out of the blue. The boys in blue. Bluebeard. Blue cheese. The deep blue sea...

red

blood red, brick red, vermilion, ruby red, scarlet, rust red, lobster red, venetian red, flame red, crimson, rose red, red-hot, rouge, carmine, russet red, poppy red...

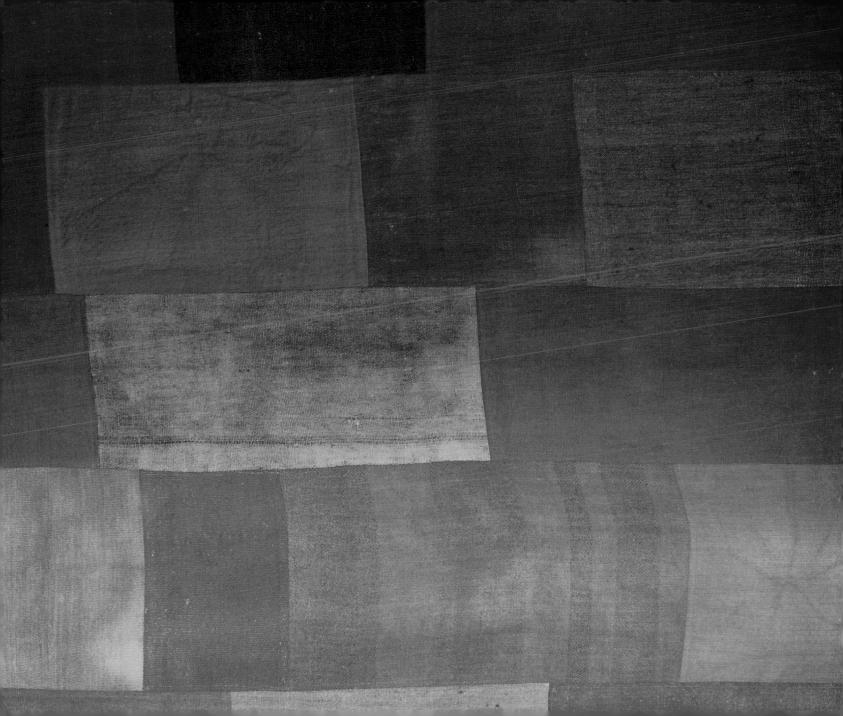

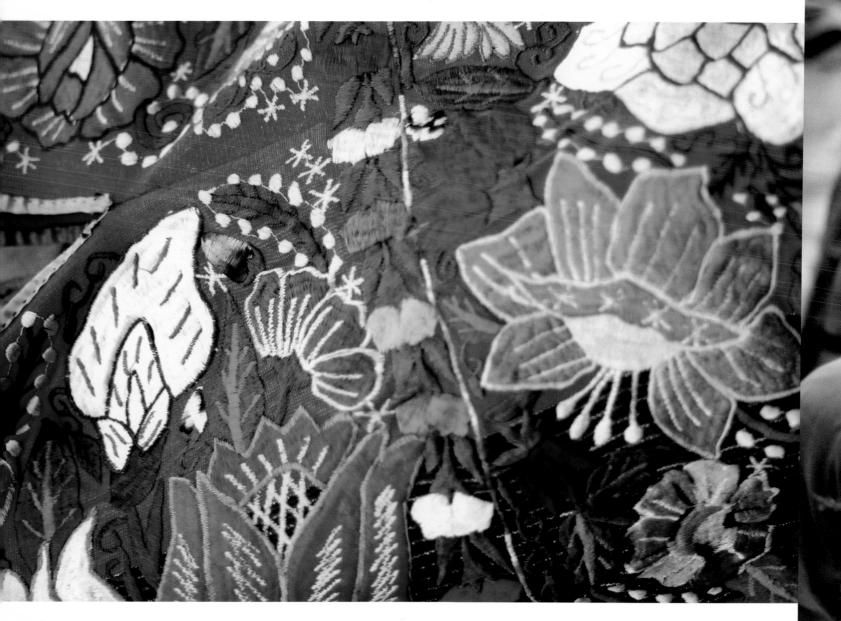

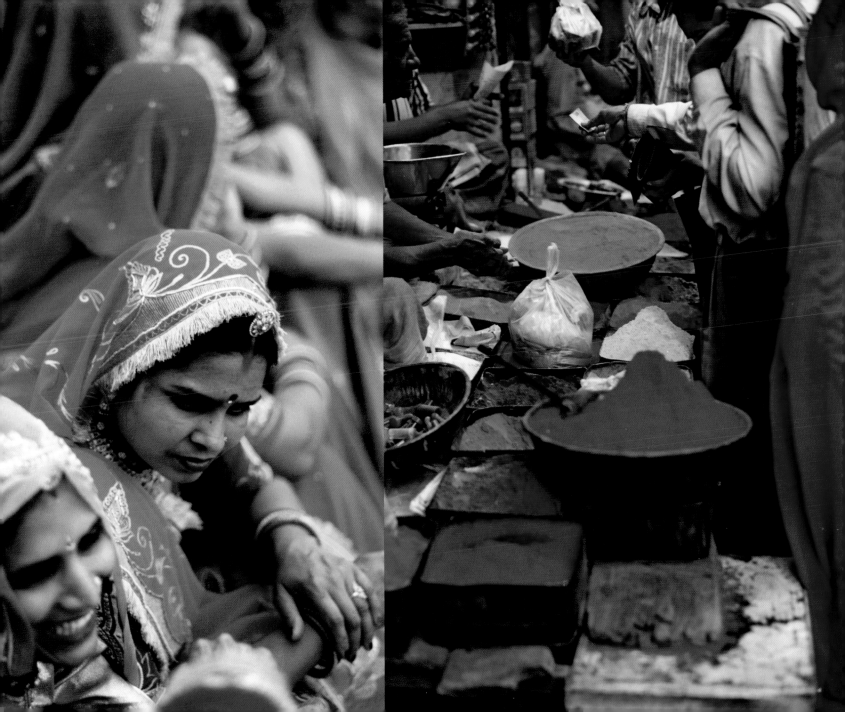

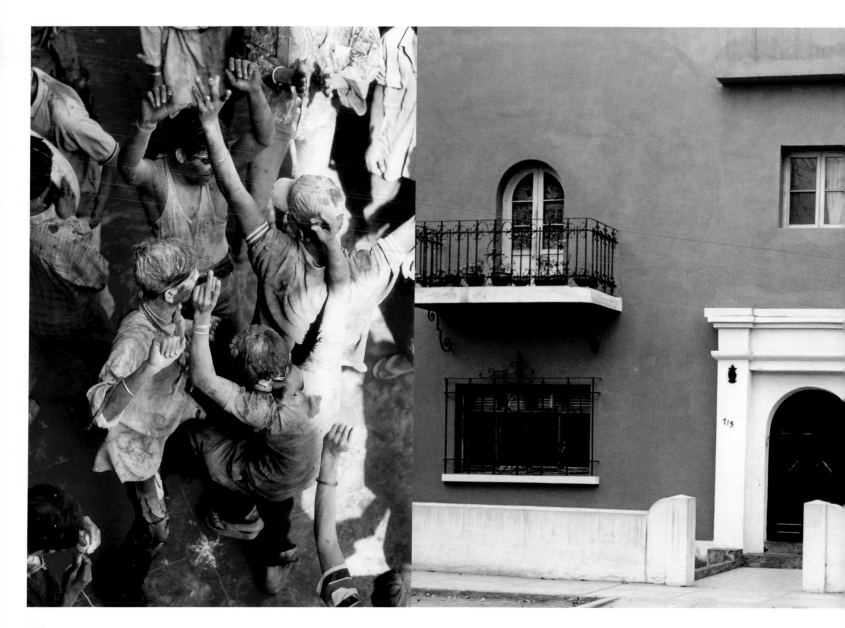

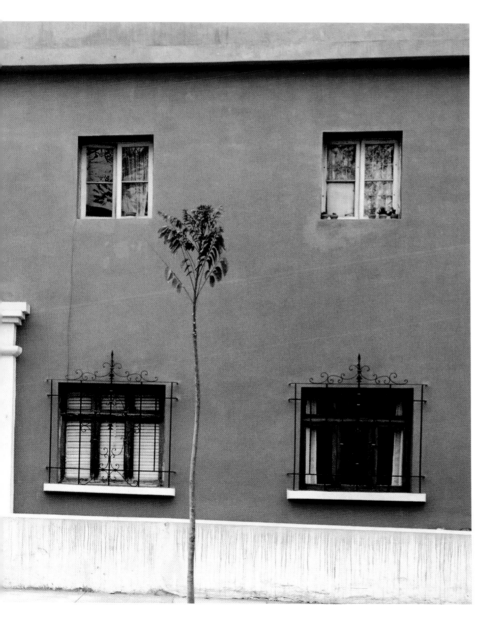

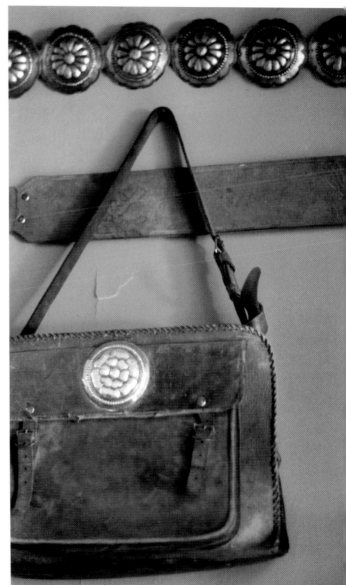

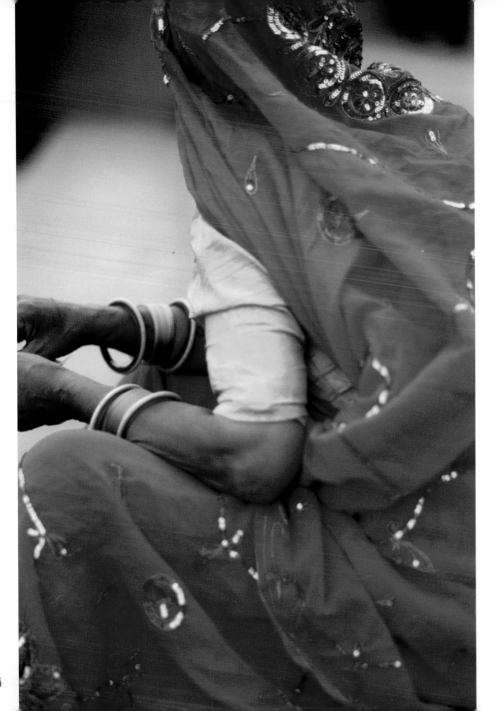

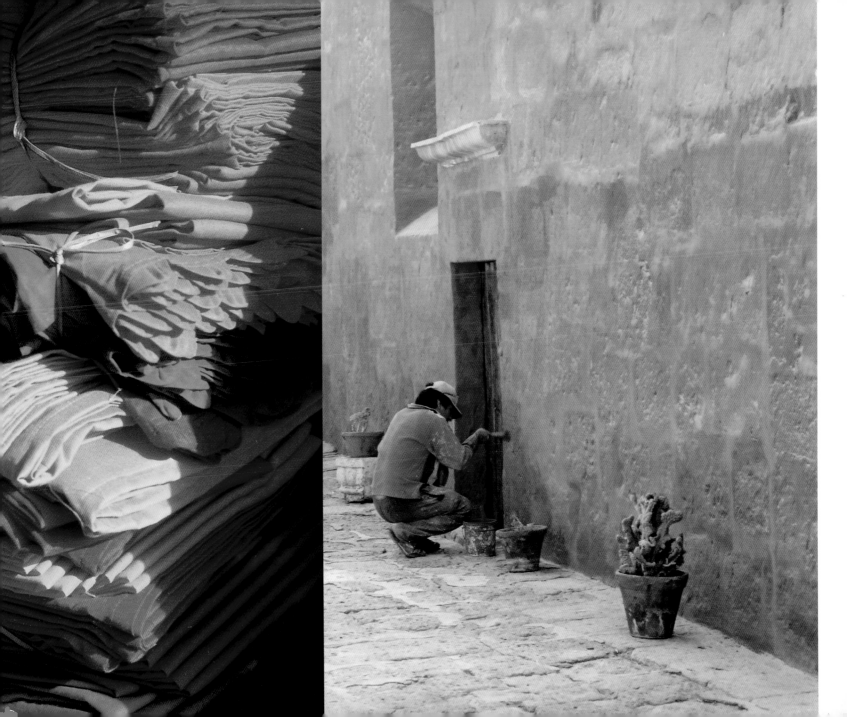

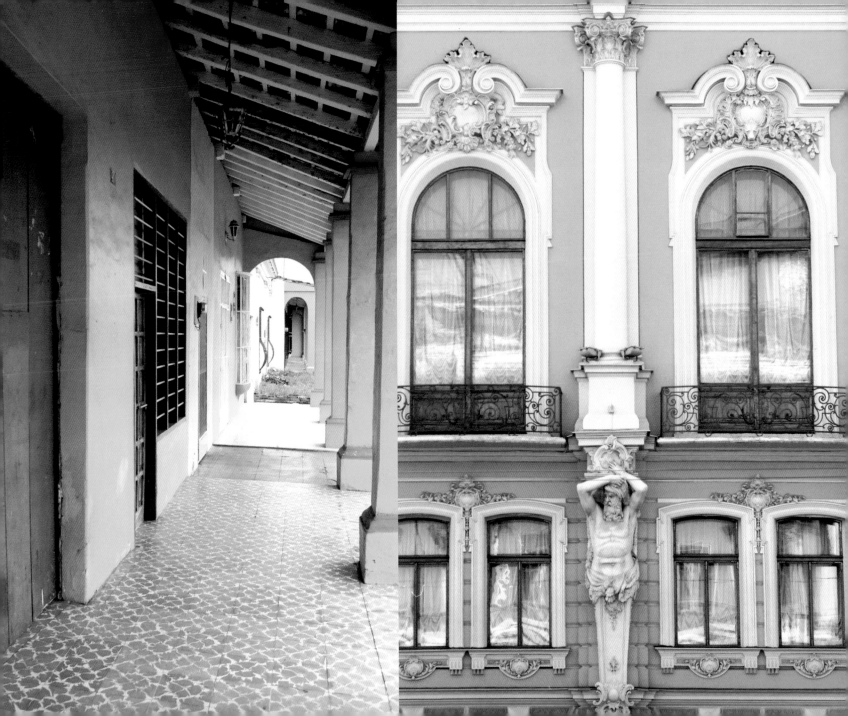

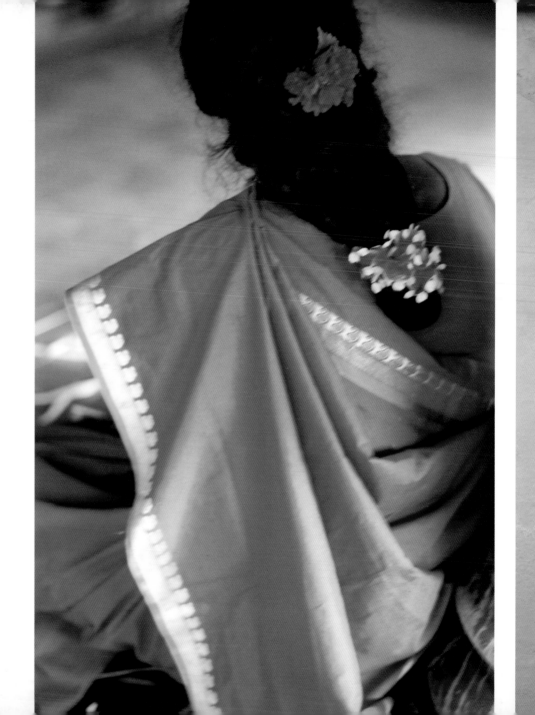

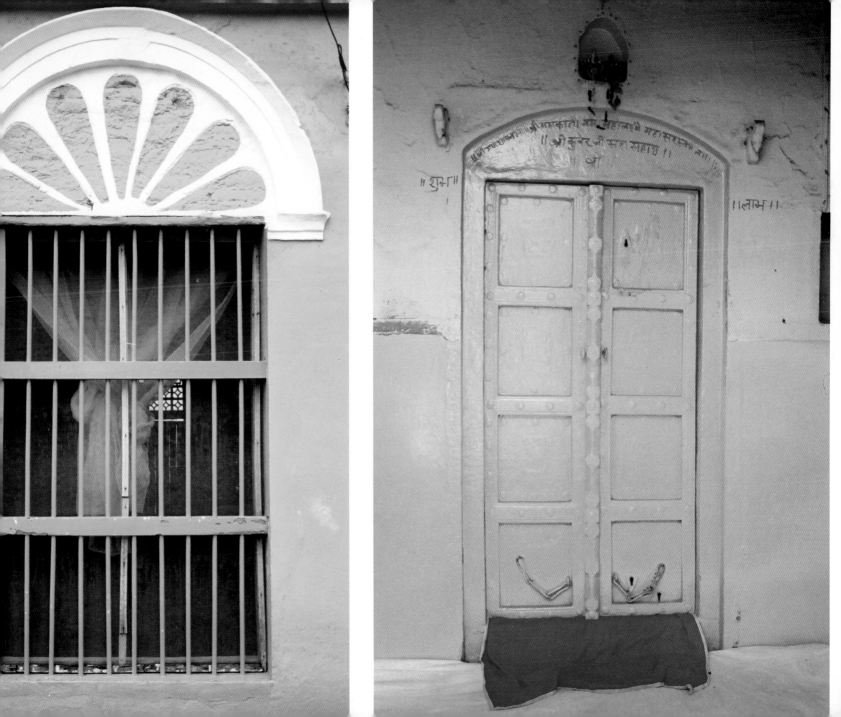

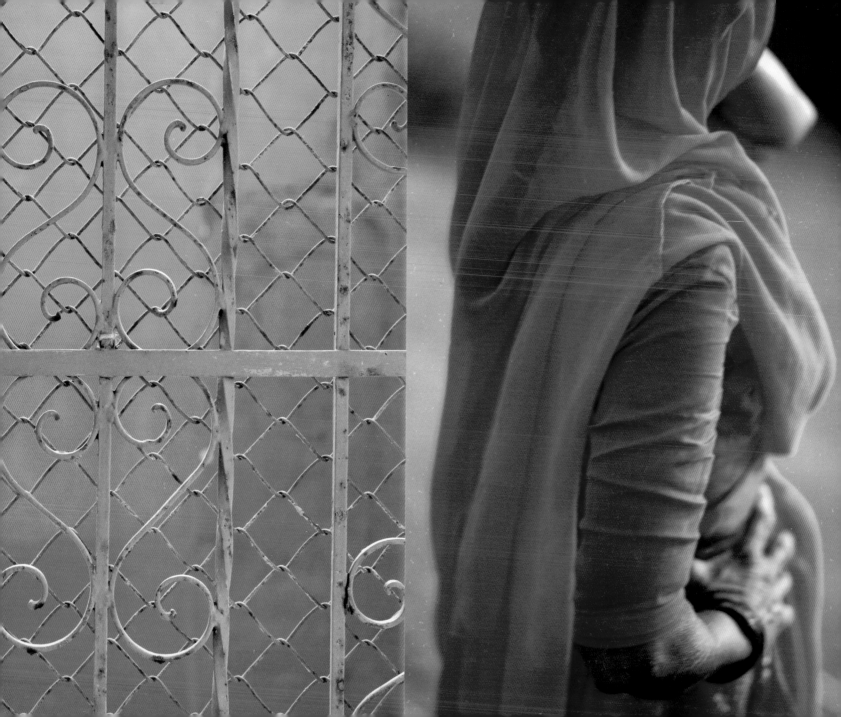

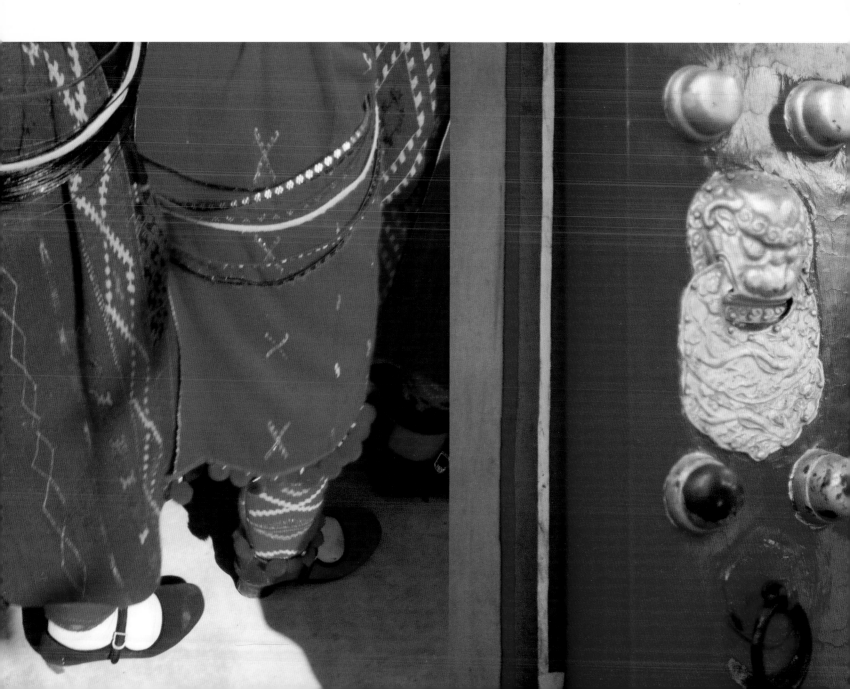

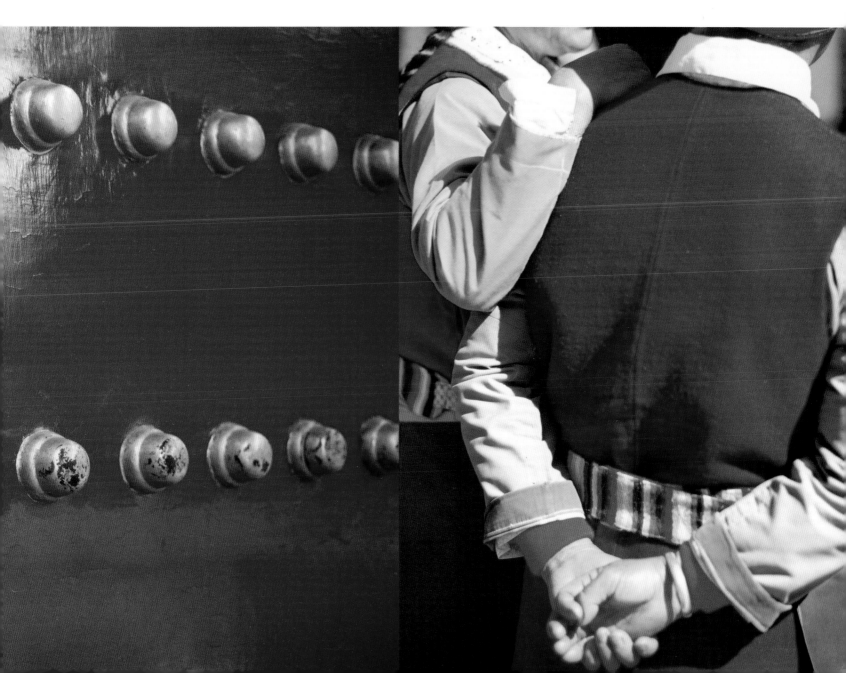

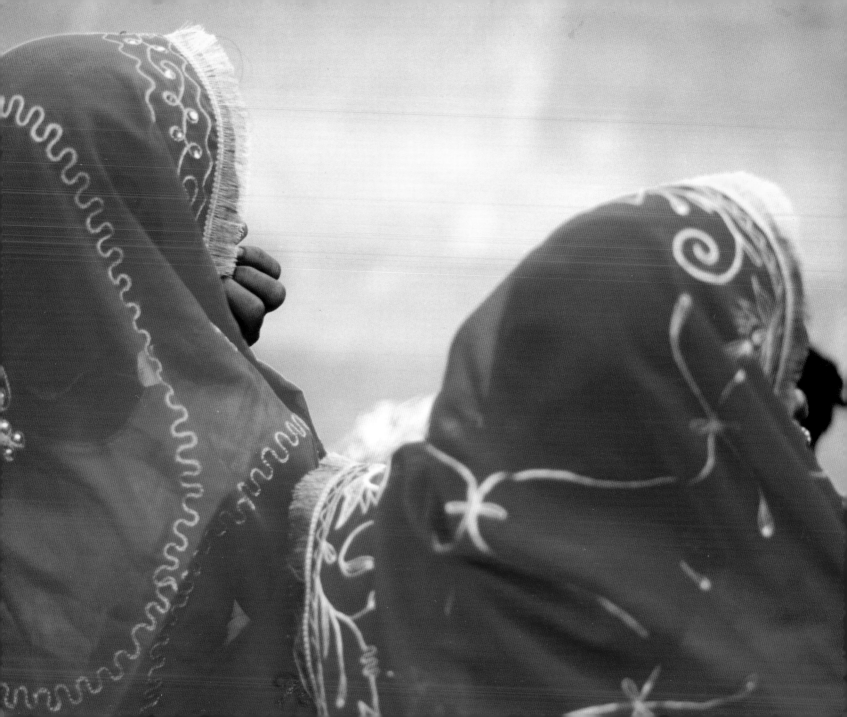

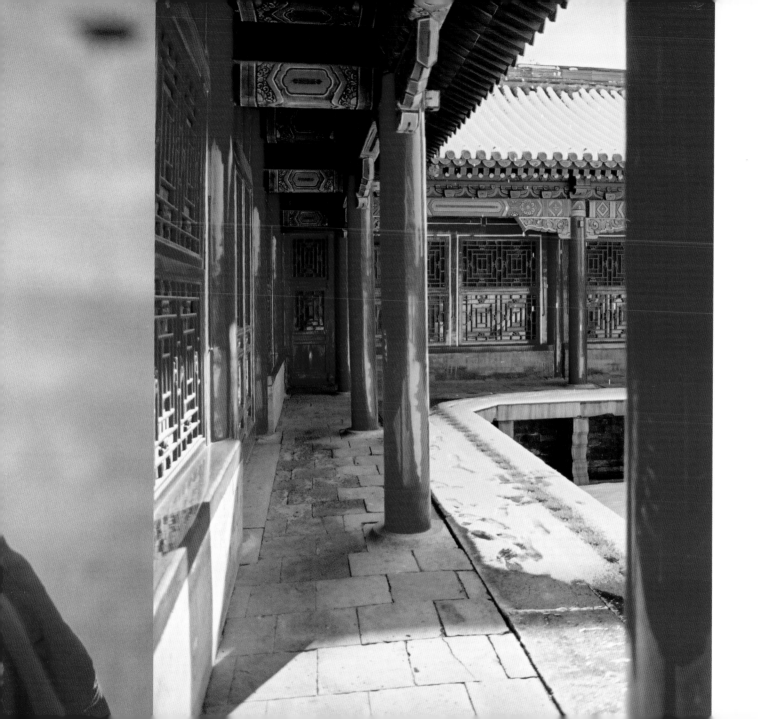

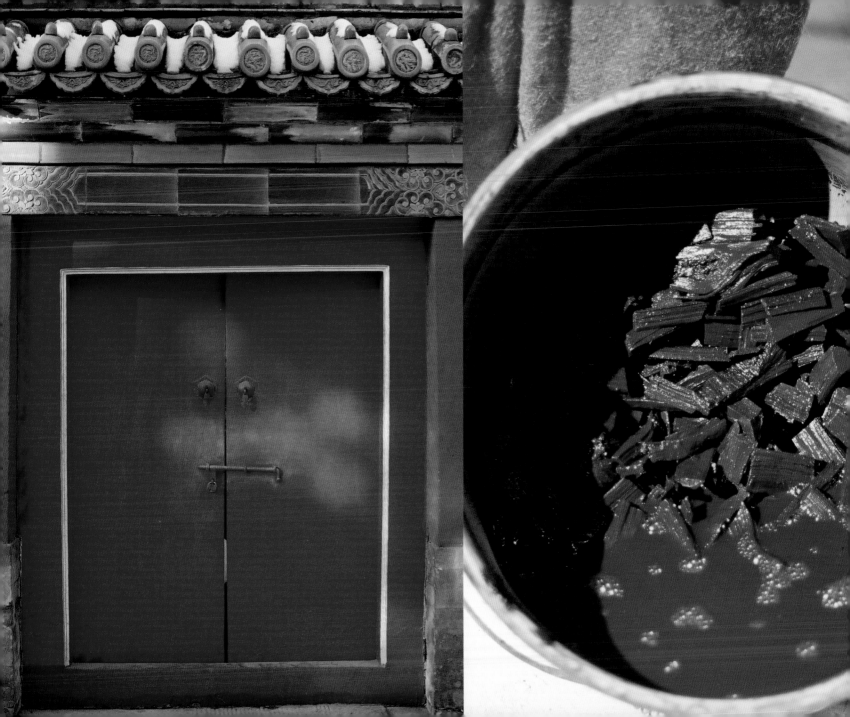

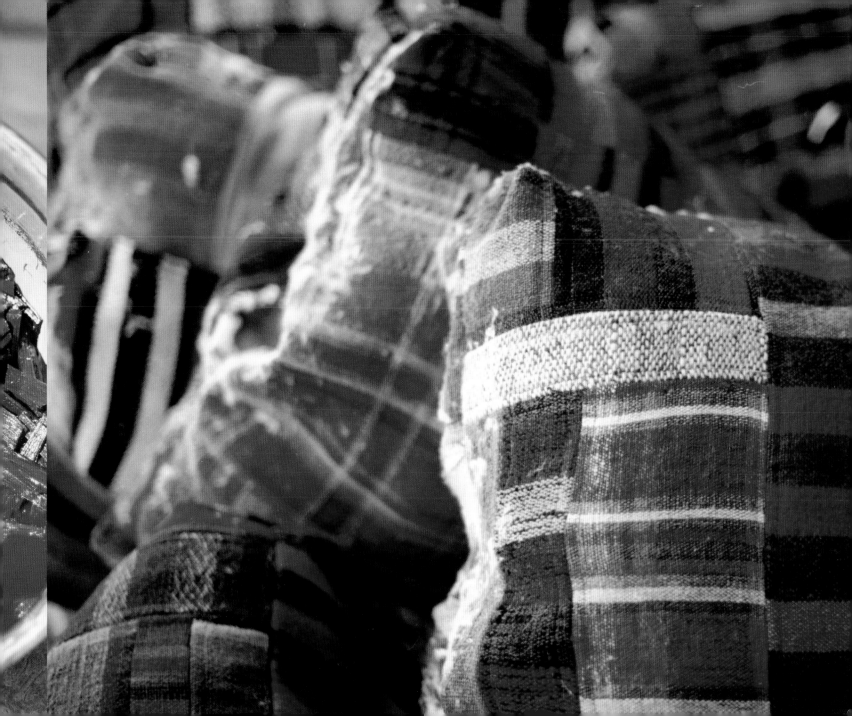

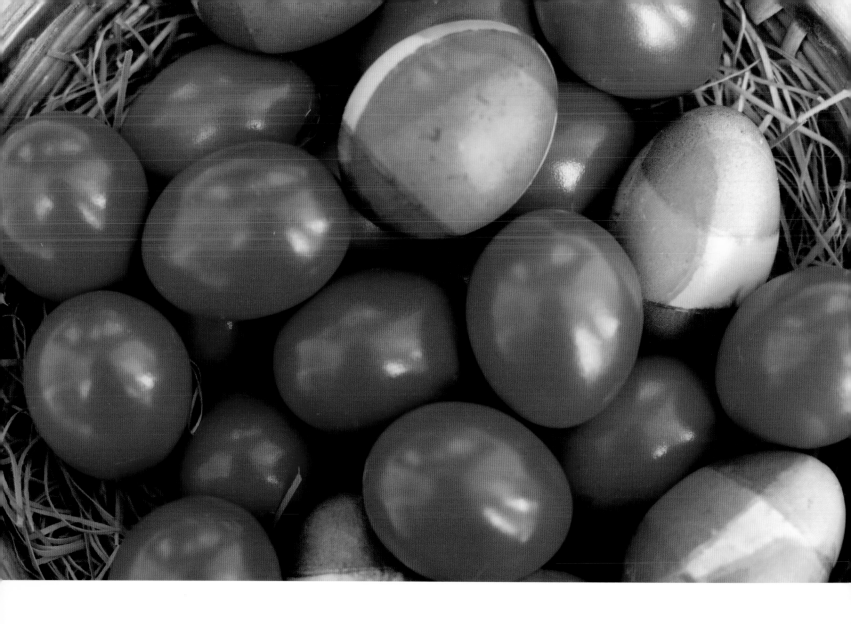

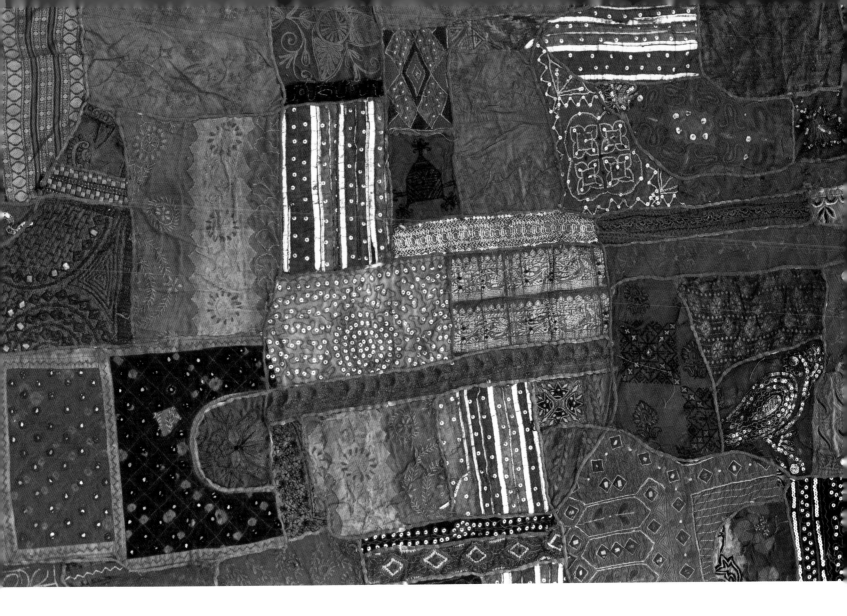

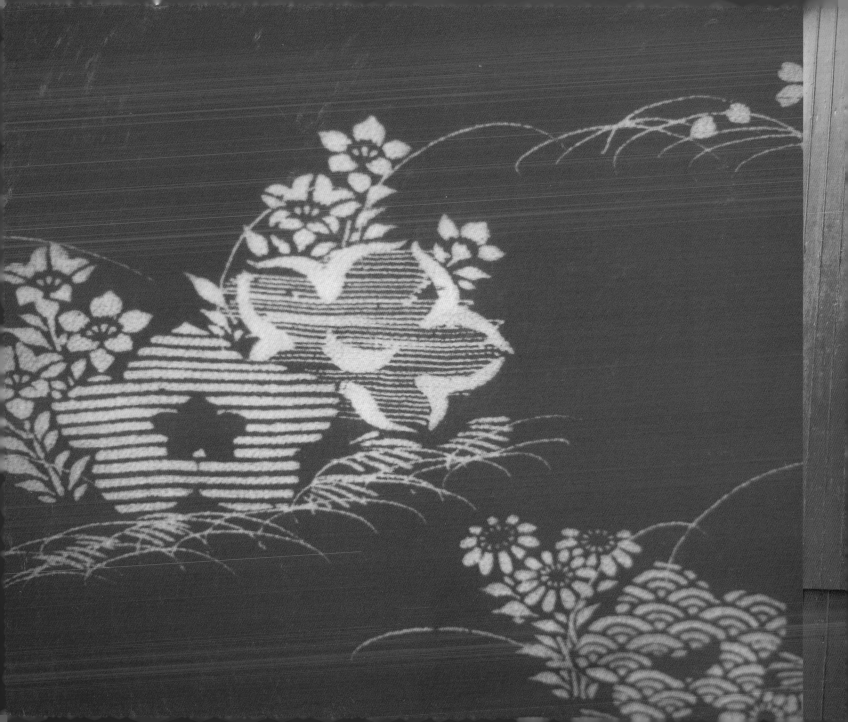

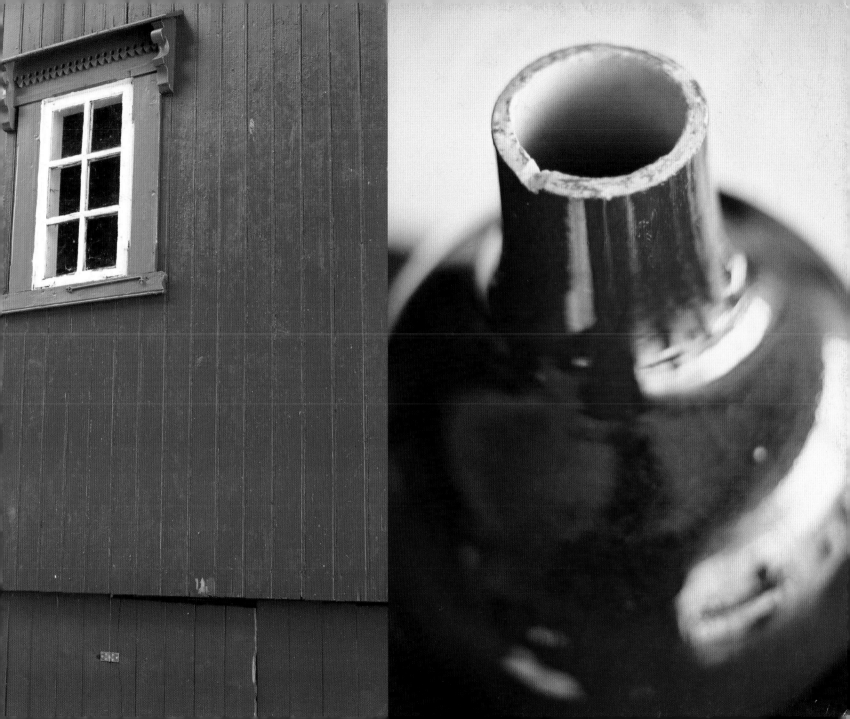

Red is the colour of all colours. When you think of colour, red is often what springs to mind. Its symbolic connotations are particularly ambivalent: it can represent the forbidden, and blood, but it can also mean power and love. The colour red has an immense hold: it can attract or repel, elevate or enrage.

Etymologically, the words for 'colour' and 'beauty' are often related to the word for 'red'. In Latin, 'coloratus' means both 'red' and 'coloured', as does 'colorado' in Spanish. In India, the same word stands for joy, hilarity, love – and to dye.

Cultures throughout the world mastered red pigments very early on, finding them in relatively widespread deposits of ochre soil, or in plants such as madder.

In Japan, the Land of the Rising Sun, red is the colour associated with Shintoism. The emperor is descended from the sun god, who is represented by a red disc. From the time when rules for colours

Be in the red. To see red. Paint the town red. A red rag to a bull. Red in the face. Red-blooded. Redneck. Red Indian. Red squirrel. Infra-red. Red

were first laid down at court, red was the colour reserved by the elite. It is the colour of life and of light. Japanese children make no mistake: they always paint the sun red.

In India, as in China, red is traditionally the colour of marriage. The 'blood sari' presented to an Indian bride by her father marks her out as a wife, and signifies life and erotic desire. In China, red is the colour of joy and celebration: bride, groom and guests all wear red, and the wedding invitations are written in red ink.

Up until the nineteenth century in Western Europe, brides were dressed in red, especially in peasant cultures. A bright red garment is still a sign of power and there is nothing more handsome or pre-stigious for many than military parade dress.

But red is also the colour of revolution, of blood spilt in battle, of danger, and of the devil.

square. Red tape. Get a red card. Red carpet treatment. The red cross. Red-brick university...

black

pitch black, blue-black, inky black, coal black, charcoal, sooty black, jet black, raven-haired, smoky black, ebony, henna black, smudgy black, mourning black, burnt cork...

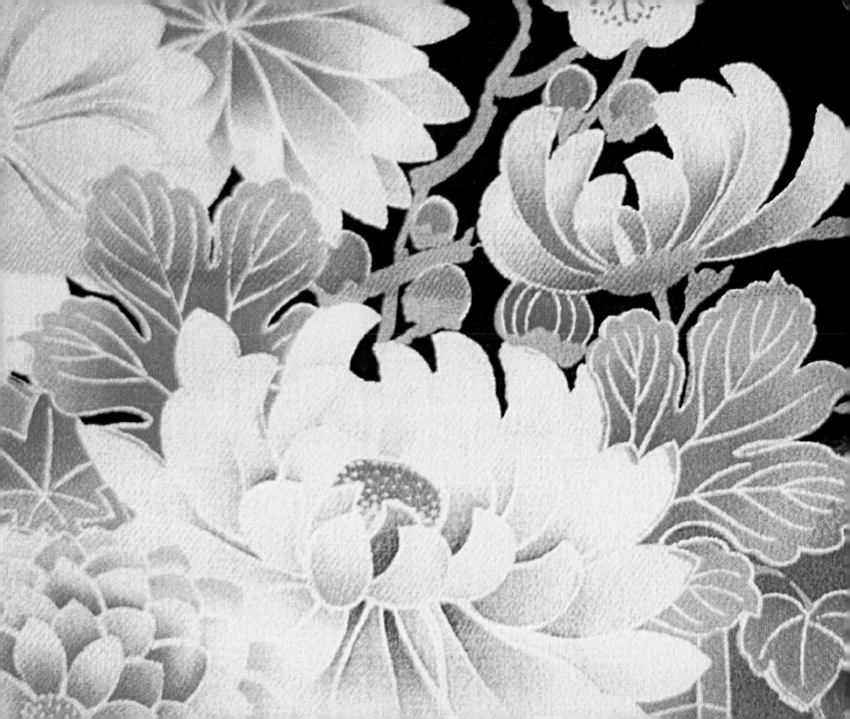

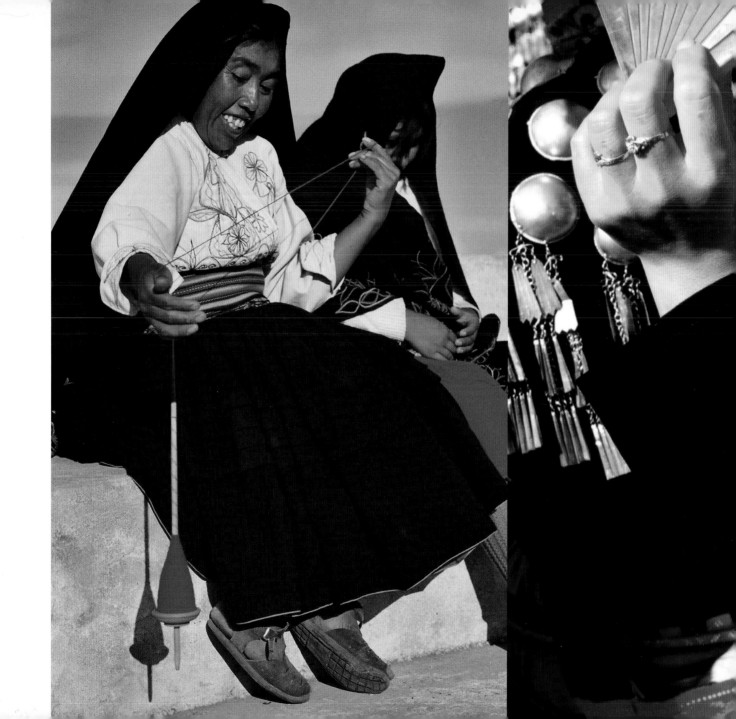

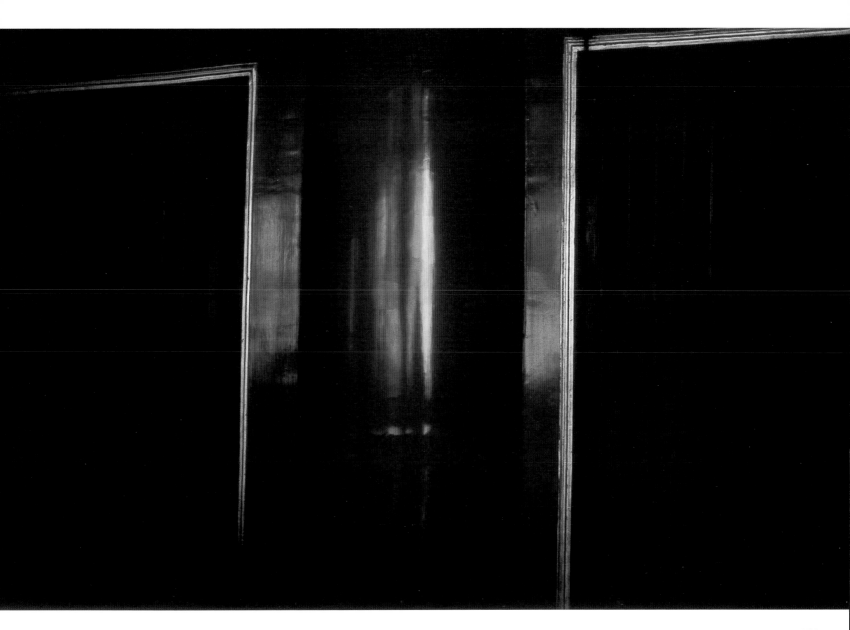

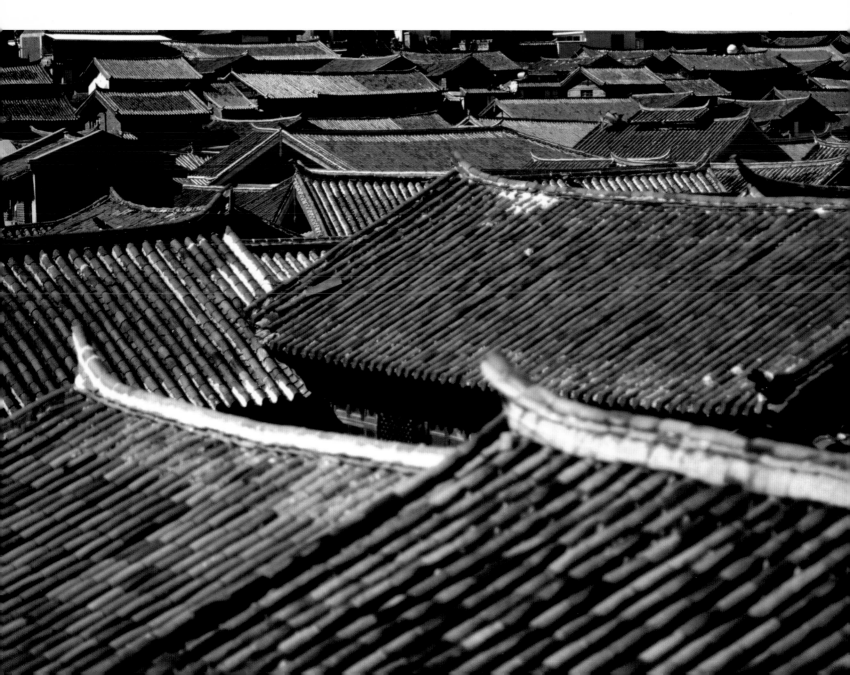

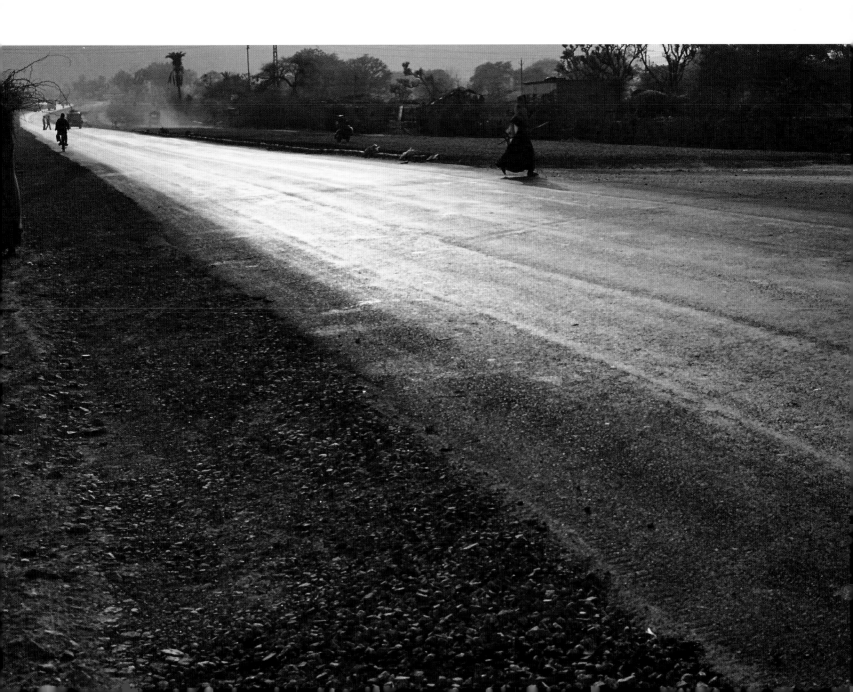

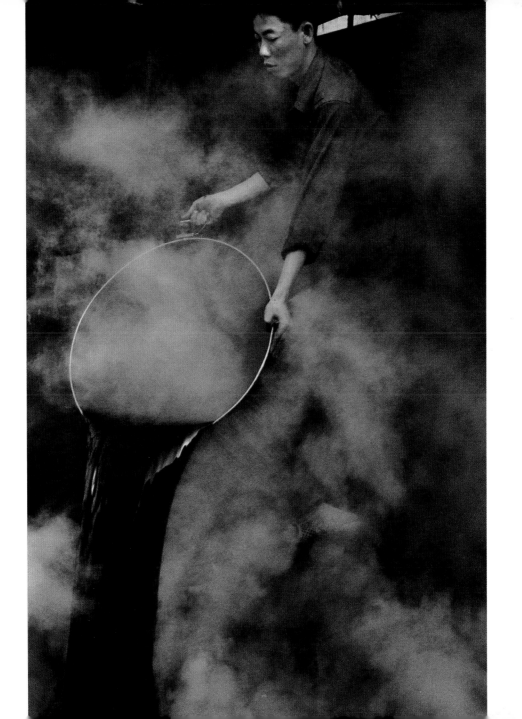

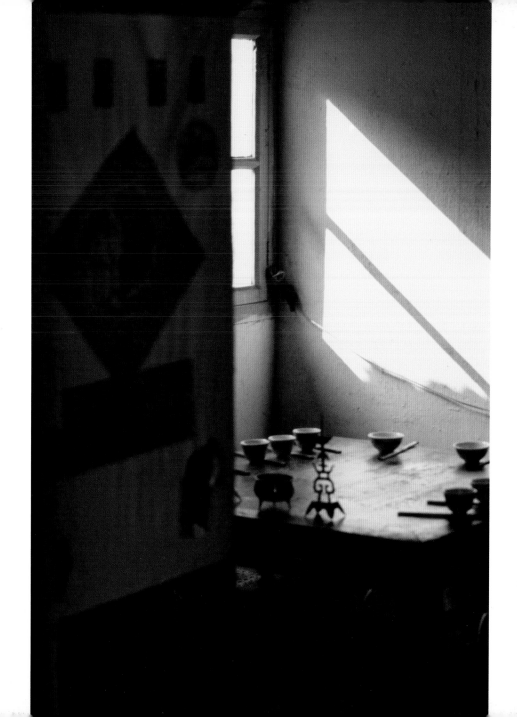

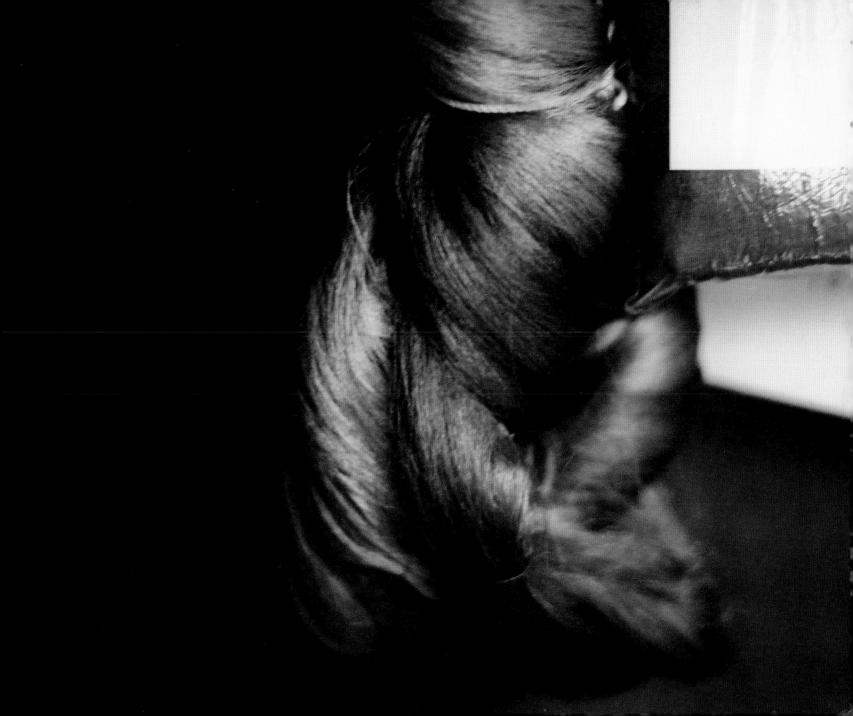

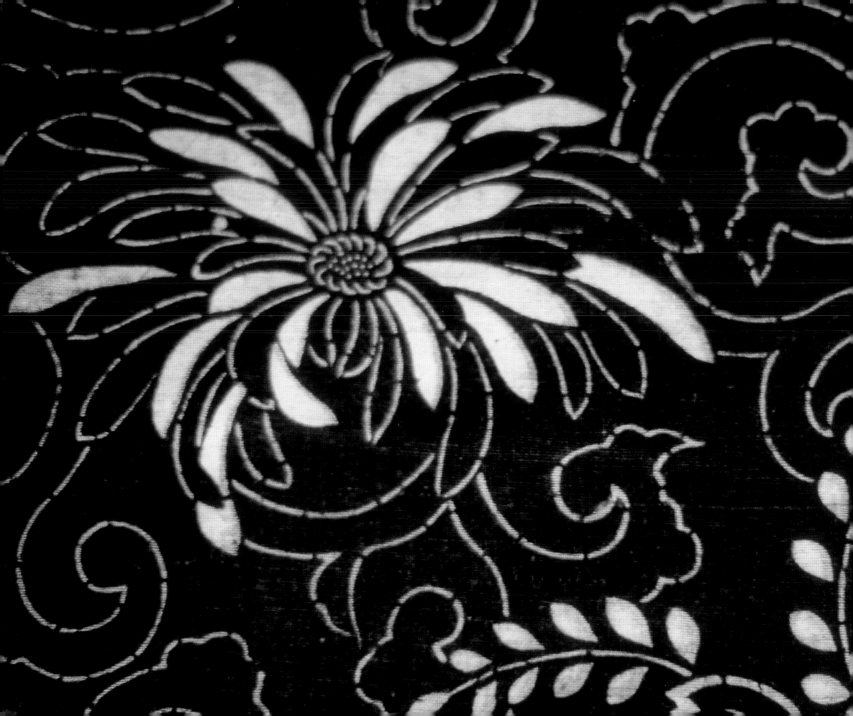

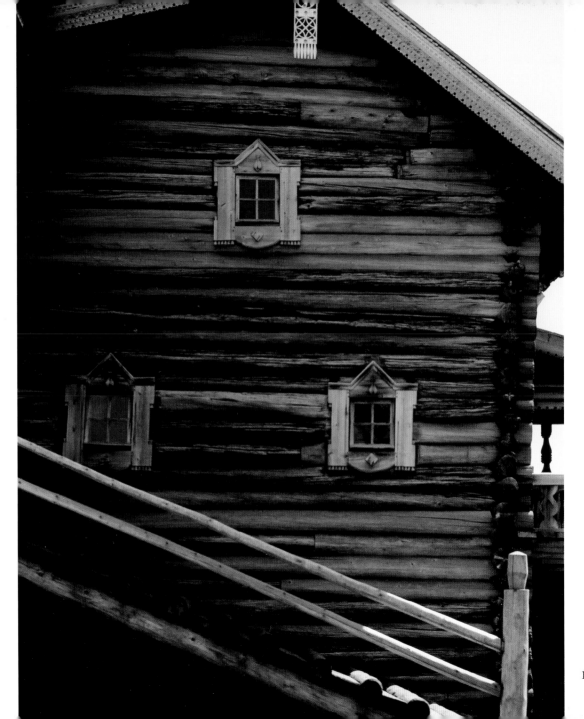

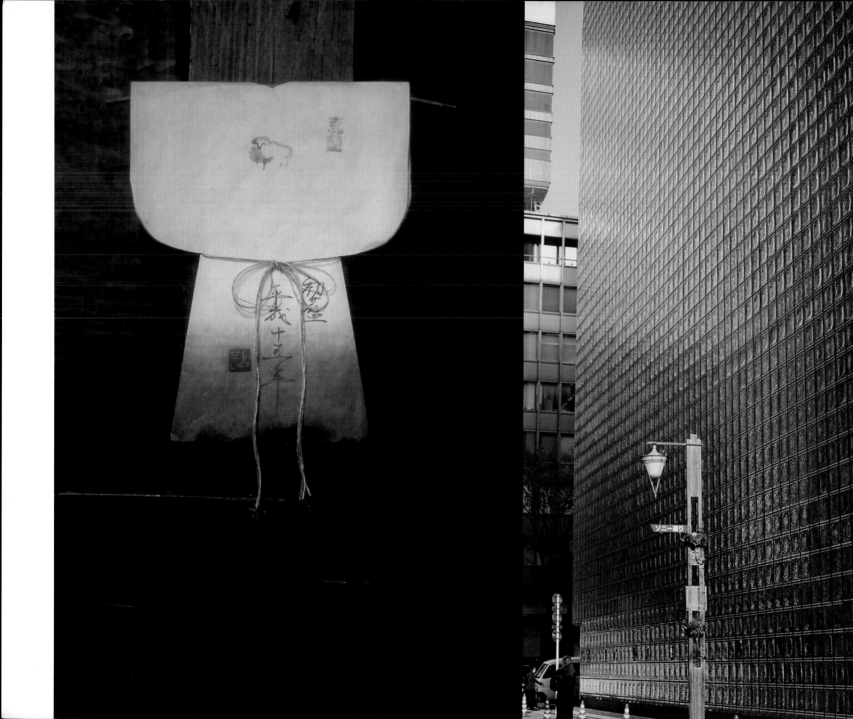

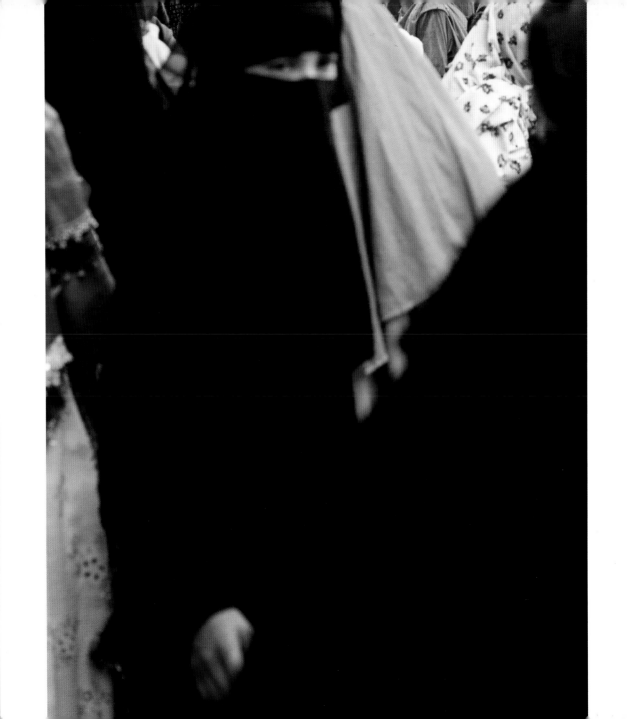

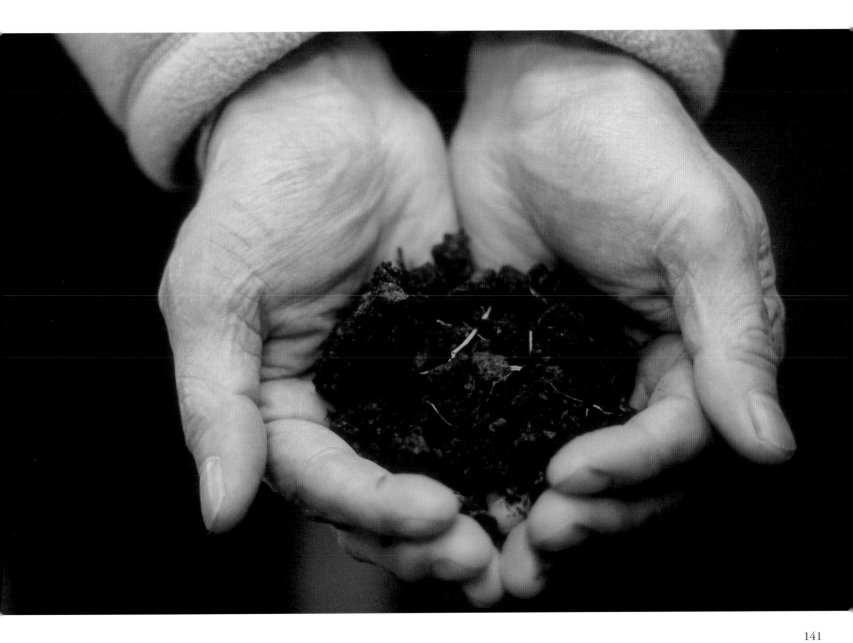

At its most basic, black is the absence of light: it is darkness. It evokes the underworld, an unknown region of doubt and mystery. It inspires fear and is by its nature associated with death, evil and hell. In classical Arabic, the root of the word 'black' alludes to a power associated with vengeance and sorrow.

In the ancient Sanskrit texts of India, dark colours such as brown, dark red, black and blue are confined to the lowest castes, and black stands for impurity and baseness.

For centuries, there was nothing to make black appealing as a colour for clothing: dyers were unable to produce strong, dense blacks, and the splotchy, greyish cloths that resulted from their efforts were worn only by the very poor. In the late thirteenth century, a passion for blue cloth led the wealthy to spend a fortune in an attempt to preserve blue as the colour of virtue and wearing black was declared immoral as a result. But in the early fourteenth century, a host of edicts and laws were

Be in the black. Look on the black side. Black someone's eye. Black and white. Black mail. To black out. Black magic. Black-eyed peas. Be in the

introduced to force people to wear black. Dyers eventually succeeded in producing really deep, even blacks, and all social classes were converted to the colour: the fifteenth century was the great age of black. In the sixteenth century, the Protestant Reformation proclaimed black, grey, brown, white and blue to be respectable, over and above other colours. This reclassification of colours favoured black, which was henceforth considered to be the colour of humility.

However, it wasn't until the seventeenth century that black replaced white as the traditional colour of mourning in Western Europe.

Black is a sign of respect, sobriety and austerity and is the colour worn by priests, judges and public officials. Yet in the tradition of the Western woman's timeless 'little black dress', black has become an obvious manifestation of classic chic, and is today synonymous with elegance.

black books. Black Maria. Black Jack. Black ice. Blacksmith. Black forest gateau. Black belt. Black box...

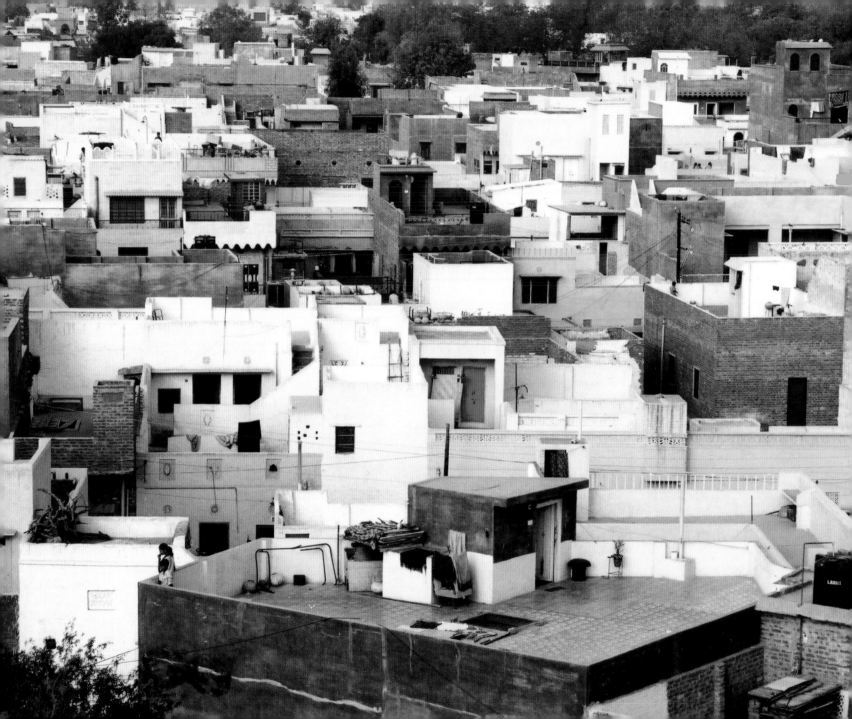

List of illustrations

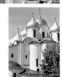

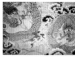

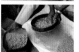

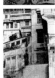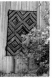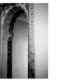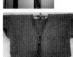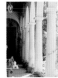

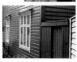
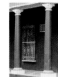

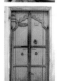

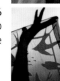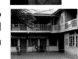

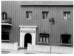

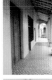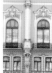

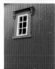

Bibliography

Bleys, Olivier, *Pastel*, Paris, 2000

Brusatin, Manlio, *Histoire des couleurs*, Paris, 1986

Cage, John, *Colour and Culture*, Thames & Hudson, London, 1993

—, *Colour and Meaning: Art, Science and Symbolism*, Thames & Hudson, London, 2000

Cousin, Françoise, *Tissus imprimés du Rajasthan*, Paris, 1986

Delamare, François and Berbard, Guineau, *Les Matériaux de la couleur*, Paris, 1999

Finlay, Victoria, *Color: a natural history of the palette*, 2003

Gœthe, *Traité des couleurs*, Paris, 1980

Jarman, Derek, *Chroma, un livre de couleurs*, Paris, 2003

Kandinsky, *De la spiritualité dans l'art et dans la peinture en particulier*, Paris, 1954

Lenclos, Jean-Philippe and Dominique, *Les Couleurs de France, géographie de la couleur*, 1982

—, *Les Couleurs du monde, géographie de la couleur*, Paris, 1999

Mollard-Desfour, Annie, *Le Dictionnaire des mots et expressions de couleur: le rose*, Paris, 2002

—, *Le Dictionnaire des mots et expressions de couleur: le rouge*, Paris, 2000

—, *Le Dictionnaire des mots et expressions de couleur: le bleu*, Paris, 1998

Neuville, Virginie, *Le Langage des couleurs*, Paris, 1996

Parramon, José, *Le Grand Livre de la couleur*, Paris, 1993

Pastoureau, Michel, *La Couleur et l'historien, pigments et colorants: de l'Antiquité au Moyen Age*, Paris, 1990

—, *Les Couleurs de notre temps*, Paris, 2003

—, 'Il était une fois les couleurs', interview with Dominique Simonnet, *L'Express*, July-August 2004

Régnier, Jacqueline, *Les Couleurs*, Paris, 1999

Tanizaki, Junichirô, *Eloge de l'ombre*, Paris, 1993

Varichon, Anne, *Couleurs: Pigments et teintures dans les mains des peuples*, Paris, 2000

Acknowledgments

Many thanks to Jean-Michel Carlos and the BBDO society in Paris, Jean-Claude Gallienne and the Central Parc society and Hermès, for all the support and confidence they extended to me.

Thanks also to the entire team at Galeries Lafayette who offered me the chance to produce and exhibit my photographs in the Galerie des Galeries in January 2004.

I am grateful to the scenographer and architect, Christophe Martin, for his enthusiasm and talent.

For hosting the exhibition 'matière couleur' in the Beaumarchais show room at the end of 2004, I also thank the Pierre Frey and Patrick Frey society

And a special thank you to all the locals and artisans who warmly welcomed me throughout my long quest for colours: Eva Kabadayan and Ali Allalou, Manny Ansar, Dialo Assa Sylla, Dramane Fane, Paul El-Hage, Abdourahmane Ag Abdou Salam, Halis, Halous Octajou, Xavier and Anahi, Laeticia and Memo Roel, Silvia Cruz Altamirano, Isabelle Morel, Hiro Tomita, Yoshioka Sachio, Shindo Hiroyuki, Sébastien Billioud, Baorong Gong, Hubert Bazin, Thomas Jan, Dharmendra Tank, Narayanan and Celaleddin Vardarsuyu.

I am much obliged to Hélène Borraz, Florent Babilotte, Véronique Prieur Laurent, Arnauld de Fouchier and Gilles de Laboissière and Barbara and Mathieu Barrois for their feedback and precious contribution to this book.

And finally, many thanks to all those close friends who gave me their constant support: Cerise, Corinne, Paulette, Hélène, Patrice, Clémence and Dominique.

And especially to Guillaume, who encouraged me to follow my dreams of colours to the end of the world.

Texts and photographs © 2005 Amandine Guisez Gallienne
Preface © 2005 Hilton McConnico
© 2005 Thames & Hudson Ltd, London

Project co-ordinator: Hélène Borraz

First published in the United Kingdom in 2005 by
Thames & Hudson Ltd, 181A High Holborn, London WC1V 7QX

www.thamesandhudson.com

British Library Cataloguing-in-Publication Data
A catalogue record for this book is available from
the British Library

ISBN-13: 978-0-500-28586-2
ISBN-10: 0-500-28586-1

Printed and bound in Hong Kong
by Sing Cheong Printing Company Limited